Inaugural Exhibition | Anacostia Museum

David C. Driskell

Contemporary Visual Expressions

The Art of

Sam Gilliam

Martha Jackson-Jarvis

Keith Morrison

William T. Williams

Smithsonian Institution Press

Washington, D.C.

London

Published on the occasion of the inaugural
exhibition of the new facility for the
Anacostia Museum of the Smithsonian Institution
May 17–July 31, 1987
Curator for the exhibition: David C. Driskell
Book design: Alan Carter
Editor: Jeanne M. Sexton

Library of Congress Cataloging in Publication Data

Driskell, David C.
 Contemporary visual expressions.

 Catalog of the exhibition held at the Anacostia
Neighborhood Museum of the Smithsonian Institu-
tion,
May 17–July 31, 1987.
 Supt. of Docs. no.: SI 1.2:V82
 1. Afro-American painting—Washington (D.C.)—
Exhibitions. 2. Painting, Modern—20th century—
Washington (D.C.)—Exhibitions. I. Anacostia
Neighborhood Museum. II. Title.
ND238.N5D75 1987 750′.89960730753′0740153
87–600094

British Library Cataloguing-in-Publication
Data is available

Cover: Sam Gilliam, detail from *Saga*
1986, acrylic/canvas, enamel and
acrylic/aluminum, 113 × 190 × 8 in.
Courtesy Middendorf Gallery, Washington, D.C.

Contents

Dedicated to the warm memory of
my sister, Virtie L. Driskell McNair,
who always encouraged my
artistry and scholarship

D.C.D.

Foreword

As the director of the Anacostia Museum, it is my delight to welcome here four of our country's most positive artistic personages. While they have already received critical acclaim, much more awaits them. I will reserve further comment concerning their work because that is the province of one of America's most respected art historians, David C. Driskell, in his essay in this catalogue.

Dr. Driskell himself does not fit into the normal conventional boxes in which we like to put people, such as "main stream," "ethnic," "abstract," "conservative," or "universal." Driskell is so rich, so rare an individual that he defies definition. Driskell is a purpose, he is a cause, carried out in a most dignified manner.

When Dr. Driskell was asked to become curator of this exhibition, *Contemporary Visual Expressions,* the inaugural exhibition of the new home of the Anacostia Museum, he responded without hesitation. I can speak for the staff of this museum when I say that it has been a joy to work with this devotee to excellence, and benefit from his quiet, sure-footed guidance.

A word of special thanks is due to Mr. Julian Euell. During his tenure as assistant secretary for public service at the Smithsonian Institution, he used his influence, dedication, and administrative skill to navigate us through the preparatory stages of forming this museum. He will forever remain very special to Anacostia.

We have been fortunate to have had in this historic moment two secretaries of this Institution who have presided over the development of this museum. Secretary S. Dillon Ripley spoke, and the Anacostia Museum was born. Since the opening of its doors in 1967, our museum has had a positive influence advancing the cause of museums the world over. In this, Mr. Ripley should take great pride. Secretary Robert McCormick Adams now intends to push ahead with projects that will enable all of our museums to become the finest research institutions in America. This should provide many exciting opportunities for those who for too long now have been on the outside.

This historical event, the dedication of our new building through this inaugural exhibition, makes us grateful to all of our colleagues. There are so many people within the Smithsonian Institution, as well as the museum community worldwide, and also many in our local audience whom we must definitely thank. Let me reiterate my thanks to the Board of Directors of the Anacostia Museum for their persistence and continued goodwill in bringing the museum this far. I must also

thank the Fort Stanton Civic Association and the residents of Fort Stanton and Woodland for welcoming us as their neighbors.

Finally, it is the present and former staff who have brought this institution into a safe harbor: to each one of you, let me express my extreme gratitude. You must know that I am proud of you and grateful.

We must also give praise and thanks to the founders of this very special museum. Whenever this museum is talked about, their names must be mentioned: Stanley J. Anderson, Charles Blitzer, Almore M. Dale, Marion Conover Hope, Alton Jones, Caryl Marsh, and S. Dillon Ripley.

John Kinard
Director
Anacostia Museum

Acknowledgments

An exhibition with far-reaching cultural consequences *Contemporary Visual Expressions* comes into being as a result of the time, interest in Black American art, and creative work of a vast number of people; without their help, this exhibition would not have come about. As curator for the exhibition, I wish to acknowledge with warmest appreciation the assistance received from John Kinard, director of the Anacostia Museum, and the valuable input given by Audrey Archer, Louise Hutchinson, James Mayo, and Sharon Reinckens of the museum staff. Their enthusiasm for the exhibition and their advice on matters pertaining to its relevance to the Anacostia community and the city of Washington aided my work immeasurably.

Most importantly, I wish to extend my sincere appreciation to artist Sam Gilliam who was offered a solo exhibition at the museum by Director Kinard, but who unselfishly insisted on inviting ceramic sculptor Martha Jackson-Jarvis and painters Keith Morrison and William T. Williams to share their art in the exhibition. These four artists have given much of themselves; precious time, professional advice, and, most generously, their own artistry, in helping to aid the progress and presentation of *Contemporary Visual Expressions*.

Moreover, my sincere thanks to my own staff who worked untiringly to meet deadlines and provide editorial, clerical, photographic, and research services that are always necessary for the success of a project of this magnitude. I am greatly indebted to Ophelia Speight, competent amanuensis and researcher, for all of the services she rendered, and to Elisavetta Ritchie my sincere gratitude for the editorial services she provided.

Lastly, but of great importance to the success of the exhibition, is the help I received from the following people: Jeanne Sexton, Alan Carter, Steven Jones, Stephen Frietch, Johnnie Douthis, Jeanie Kim, Toni Jackson, Shelia Parker, Charles Phillips, Otto Nelson, Jarvis Grant, Dawoud Bey, Dr. Jontyle Robinson, Janet Levine, Dr. Jacqueline Bontemps of Hampton University, Drs. Arthur Bacon and Roland Braithwaite of Talladega College, Lou Stovall of Workshop, Inc., my wife Thelma Driskell and the Driskell family during the period of preparation for this exhibition.

D.C.D.

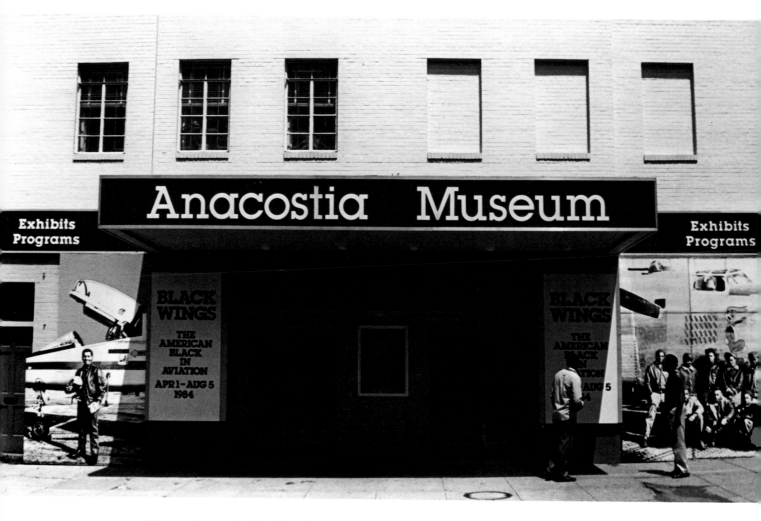

Figure 1. The original building that housed the
Anacostia Museum.

*The Anacostia Museum
as a Cultural Legacy*

The best-kept secret in Washington, D.C., better known for highly charged international and domestic politics, but currently enjoying an unprecedented cultural renaissance, is our highly respected community of Black visual artists—graphic artists, painters, and sculptors. Few African American communities, other than New York's Harlem of the 1920s, can boast such an outpouring of scholarly and creative productivity. And the generous spirit of artists-helping-artists has been vital to the process. The lineage of our service to each other and to the broader public, not only as creative artists, but as arts administrators and educators, is proud and vital. Organizations and institutions, but most of all people, have played key roles in developing progressive cultural leadership in a city not always attuned to the aims of creative individuals nor to the public's need for cultural nourishment beyond what is offered by the vast national museums.

Washington, still second to New York as a showcase for visual and performing arts, is now moving toward a broader-based cultural zenith with the addition of major exhibition facilities for several Smithsonian museums: the new building on the Mall for the National Museum of African Art, the new Arthur M. Sackler Gallery, the highly acclaimed critical and historical programs of the Visions Foundation, formerly at the National Museum of American History, and now the gallery in the new home of the Anacostia Museum. Moreover, the role itself of the museum has broadened to reflect its impact on the national scene. It brings to our attention the history of African American culture through people in education, government, religion, and the arts, a mantle it inherited out of the long tradition that began around Howard University.

Yet more remains to be done in bringing together art and audiences. Over the last two decades increasingly larger and larger audiences have been attending exhibits in this city. An equally impressive number of individuals helped to found galleries and centers where artists' works are seen daily by an ever-greater number of viewers. Such an important demographic change in gallery statistics should normally bring with it noticeable progress in the socio-cultural patterns that define cultural largess.

Not so in our capital city. Many local artists, especially women, Blacks, Asians, Native Americans, and Hispanics, complain that they have lacked the normal support systems available to white male artists. Museum directors and, in the private sector, commercial art

dealers, historically have not seemed willing to ensure that the works of minority artists are regularly exhibited at the city's galleries and museums. Thus the chances of minority artists gaining audiences among the majority culture are limited. So are the museum-based curatorial promotions that normally encourage patronage and enlightened connoisseurship in the fine arts. One cannot help but ask why, in a city that is approximately 70 percent Black and Hispanic, so few minorities are employed in top-level administrative and curatorial positions in its museums. The question becomes even more relevant since the major programs at both the Anacostia Museum and the National Museum of African Art mainly represent the art of African peoples and the descendants of Third World cultures. As our capital city approaches more enlightened cultural maturity and visual literacy, it is high time for all the city's cultural institutions to reassess their hiring policies.

Figure 2. Architectural drawing of the new facility for the Anacostia Museum.

The Guiding Role of the Anacostia Museum

Since September 15, 1967, when the Anacostia Museum opened its doors to the public, it has demonstrated its commitment to the task of informing the entire community of the salient contributions that Black Americans have made to the social, political, and cultural history of the capital city and the whole nation.

Anacostia, an area which lies within the legal boundaries of the District of Columbia, was transformed from a prosperous farming community in the late nineteenth century into what is today a lower-income urban area, predominately Black. In many ways, Anacostia remains both within and without the larger city. It has lacked the major governmental, cultural, and economic-producing facilities for which the capital is internationally known. Other than schools and churches, the community has had few cultural centers. But its citizens are its most precious resource, and the Anacostia Museum is trying to serve their interests as well as those of the entire Washington community by presenting thought-provoking and significant exhibits and publications. In so doing, the museum is managing to fill many of the cultural gaps which the capital's other visual arts institutions are not yet undertaking.

A Lineage of Artistic Cooperation

In offering flagship exhibitions on Black culture, the Anacostia Museum is fulfilling the role originally assumed by Howard University and the Barnett Aden Gallery. The museum is both continuing and expanding programs that these two institutions inaugurated between the 1930s through the late 1950s. Long before there was the dream of such a neighborhood museum, artists and scholars at Howard University worked together to promote the arts. They saw themselves as the true defenders,

definers, and presenters of Black culture in the nation's capital.

To this camp of dedicated scholars came Alain LeRoy Locke, aesthetician/philosopher and the nation's first Black Rhodes Scholar; James V. Herring, artist/educator and founder of Howard University's art department; and James A. Porter, artist/art historian whose writings on African American art remain widely consulted. Lois M. Jones, a painter from Boston, and James L. Wells, a print-maker from New York, joined Herring and Porter in Howard University's art department.

These four artists/educators worked with Alonzo Aden to establish the first professional art gallery at a Black university in the United States. On April 7, 1930, they founded the Howard University Gallery of Art on the ground floor of the Andrew Rankin Memorial Chapel on the campus. Artists on the art department's faculty often participated in group shows at the gallery; moreover, they invited other artists from the city to exhibit there. More than 250 exhibitions of works by African, Black American, Asian, Native American, and white American artists were held at the Howard University Gallery of Art from 1930 until the Anacostia Museum opened to the public in 1967.

One of the promising young artists whose work was shown in the 1940s at Howard University was John N. Robinson from Anacostia. Largely self-taught, but benefiting from the encouragement of older artists like Herring, Jones, Porter, and Wells, Robinson painted many cityscapes which depicted in detail the hills and houses of that section of the city. Robinson's exhibition in 1982 at the Anacostia Museum included a wide range of landscapes, family settings, and still lifes which reflected both realistic and surreal styles of painting.

Such has been the successful lineage of an expanded family concept of artists-helping-artists in a community in which patronage was

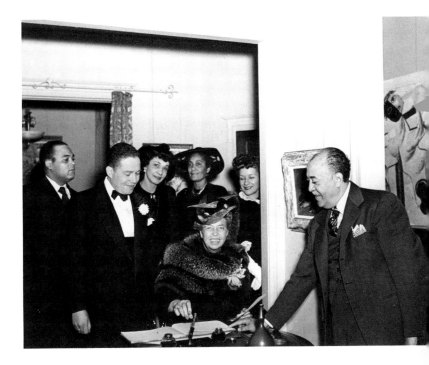

Figure 3. Eleanor Roosevelt at the Barnett Aden Gallery. *Far left*, John Shufford; *left*, Alonzo J. Aden; *right*, James V. Herring. Courtesy Professor and Mrs. David C. Driskell.

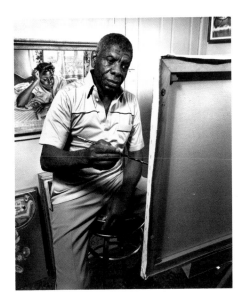

Figure 4. John Robinson at his easel, ca. 1982

too often limited to family and immediate friends, and exhibit space for Black artists, as Professor James A. Porter has written, was usually limited to "the churches, the vestibules and reading rooms of public libraries and YMCA buildings, or the classrooms of public school buildings" ("Progress of Negroes in Art During the Past Fifty Years," *Pittsburgh Courier,* July 1950). To this day, such locations still provide the most usual—but often inadequate—space for Black artists to share their work.

On one hand, these types of locations serve to keep artist and sources of inspiration and audience in close touch—as the French writer/philosopher Albert Camus wrote, if the artist distances himself from the give-and-take of a living community too long and retreats into an ivory tower, he loses the very wellsprings of his creativity. Nonetheless, limiting the artist to a few small local exhibit halls also limits the chance to reach broader audiences.

For too long only certain private institutions within the city, such as the Barnett Aden Gallery, Smith-Mason Gallery,* and, more recently, the Evans-Tibbs Collection and the Washington Project for the Arts, all of which operate not-for-profit facilities for visual arts, have had to bear full responsibility for exhibiting and housing works of art by minority and women artists, works which should be a part of our national trust. Little of what is available at the Anacostia Museum is exhibited elsewhere in the city. Other public and private cultural institutions here should take more initiative in presenting works by these artists to the larger community, both in the cultural centers of Washington, such as the Mall and the downtown gallery districts, and in residential and working neighborhoods throughout the entire city. Thus a viable exhibition program must remain an important part of the museum's work, and should be extended to arrange for exhibits to travel throughout the city, the nation, and abroad.

Porter further points out that Black artists "were also handicapped by an absence of that critical interest in their work which is usually exercised for good or ill by the art critic or connoisseur" (*Pittsburgh Courier*, July 1950). We hope that this current exhibition and the inauguration of the expanded gallery space will bring not only these particular artists but minority artists in general more vividly to the attention of mainstream American art circles.

Figure 5. Alonzo J. Aden at the Barnett Aden Gallery in 1950. Courtesy Professor and Mrs. David C. Driskell.

*The Barnett Aden Gallery and Smith-Mason Gallery no longer offer exhibition programs. The collection of the Smith-Mason Gallery was recently donated to the Howard University Gallery of Art.

The Anacostia Museum's Expanding Role in Scholarship and Enlightenment

The Anacostia Museum's invigorating program of scholarly research that has characterized its exhibitions points up its leadership in bringing to the nation's attention many facets of Black visual and material culture in Washington's history that had not been highlighted before. Among the most important projects were *The Barnett Aden Collection,* presented in 1974, a survey of the permanent collection of one of the nation's oldest and most influential galleries devoted primarily to exhibiting the work of Black artists at a time when their art, for racial reasons, was not shown in the major galleries; *The Anacostia Story: 1608–1930,* that illuminating journal which chronicles more than three hundred years of history on the banks of the Anacostia River, so ably written by cultural historian Louise Daniel Hutchinson, for fifteen years the museum's director of research; and in 1981, also to Ms. Hutchinson's credit, an equally informative document, *Anna J. Cooper: A Voice from the South.*

Thus the museum continues to move forward in its efforts to inform the public of the fine work that Washington's visual artists are creating.

A large number of Black painters and sculptors have succeeded in remaining productive despite the difficulties encountered along the way to becoming professionals. Much of their success is due to the extended family of artists concept that nurtured a sincere outpouring of commitment to the highest standards of art. Thus, for example, without the budding artistry of a John Robinson, whose painting was encouraged by Herring, Aden, Jones, Porter, and Wells, there would be no tradition in place to encourage the success of future generations of artists. Many of the artists whose grounding has been in Washington over the past several decades—Alma Thomas, Delilah Pierce, Richard Dempsey, Sam Gilliam, Malkia Roberts, Lou Stovall, Sylvia Snowden, Bill Taylor, Georgia Jessup, Yvonne Carter, and this author included—are individuals whose artistry benefited from the outreaching philosophy of benevolence and guidance from the acknowledged leaders in the field.

The Anacostia Museum is continuing the cultural mission begun over fifty years ago by the artists and scholars at Howard University and other Black institutions in the city: the mission of enlightening all the citizens of the Washington metropolitan area—and those in towns and lands beyond this capital city—about the cultural contributions of Black Americans in the fields of fine arts and material culture.

David C. Driskell
Curator
Professor of Art
University of Maryland at College Park

A Fellow Artist's Statement

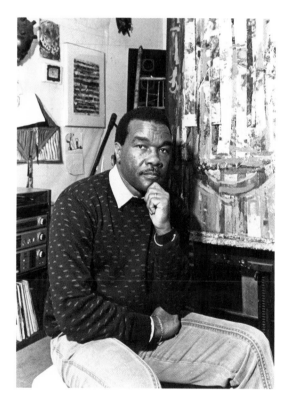

Figure 6. David C. Driskell

Art is a special calling, even priestly in function. As artists we are reaching out to our fellow men and women in a particular way. We are extending ourselves as we strive to extend the human spirit over physical matter.

We want to paint what we feel, and to my mind, feeling always goes beyond the physical—it takes us close to a kind of spiritual definition of form. We attempt to imbue our work with a certain kind of passion and flavor which goes beyond the academic or traditional notion of being controlled by the physical presence of the object. So we are extending ourselves through the spiritual element when we deal with the symbolic presence of a form.

Environment has much to do with how we see the world and interpret it. How we develop, and how the content of our work develops, and derives from our experiences. But we are also influenced by other people in general and, in particular, by other artists.

In the more traditional African societies, the artist does not turn to art to receive inspiration. The artist goes to real life and draws from living experiences which dictate the soul of his work.

In Western art we still draw from live models, but now we are looking for something that reaches beyond the physical appearance of the model or object. We are always search-

16

ing for something beyond that which we know, without robbing ourselves of our vital experiences.

As Black Americans, and particularly as Black American artists, we wear the badge of proud and ancient cultures in our Black skins. Yet we experience the haunting shadow of an African past without knowing its full richness. In our training as artists, and in our art, we are heavily imbued with Western, with European, forms. The fact that we make art the way we do—to free ourselves as individuals and to give new dimensions to our lives and hopefully to the lives of others, making our art essentially for decorative purposes, not for functional or religious ends as is done in African societies—sets us in the Western camp.

But we are American artists even though we are frequently categorized under the subtitle of "Black American," or in the old days, "Negro-American artists" when exhibiting in white-dominated museums and galleries. For some, this is irritating—yet it can also be a source of our strength.

Even those of us who might have been born and raised in the North, and/or gravitate to such traditional artists' meccas as Paris or New York (especially Harlem, that city within a city where African American artists congregated in large numbers, especially in the 1920s and 1930s), we nonetheless all draw from our Southern heritage.

Part of the passion we derive from our Southern heritage is that indescribable aura which still runs in every Southerner's blood—the notion that, Black or white, you are separate and different from other Americans elsewhere in the country. Not just in speech patterns, but in thinking, in the way of life, the kinship which developed between all peoples regardless of race and which crossed the superficial boundaries imposed upon us by tradition. We go back to our natural instinct to romanticize ourselves and our environment.

Southern writers, Black and white, keep returning to the same images. So too Black American artists—though we may live, study, and paint elsewhere in the United States and Europe, and though we may choose to create abstract and/or non-representational works—we can scarcely avoid sooner or later returning to the strong images of our childhood, to our cultural, racial, and geographic roots for inspiration.

For in the midst of the physical poverty in which many of us who grew up in the rural South either observed or experienced directly, there was a sense of the spiritual which still haunts, still nurtures us. We can neither forget nor outgrow our memories of the natural beauty of the landscape with its particular colors and textures—the different light of a Southern sky, the dusty orange-beige soil cracking in drought or turning rich brown in the rain, the variations of red and grey of weather-beaten barns and houses.

Moreover, we remember the kindliness and generosity of people, the way they talk about life, the ideals and moral principles they tried to instill in us, the rural folk tradition that embodies something pure and honest, and also the role of the Black church—not simply the religious experience and feeling of community, but the dynamics, the passion, fervent belief, and idealism. All this fostered our creativity, our way of looking at the world and of communicating with others.

Black Americans who live in Northern cities, too frequently deprived of the scenic countryside and the sense of extended kinships that big cities tend to destroy, nonetheless have the Southern experience, for better or worse, in their blood. It shapes the way we think and create. Furthermore, stretching behind that heritage we have forever the vast African continent which exerted multiple influences—Christian, Islamic—on its own infinite subcultures.

Therefore, given our particular situation as Black artists in a mixed society, we feel a special need to help each other from one generation to the next. We are a strong and extended family of artists. We strive to maintain the unbroken circle even though we add to its dimension.

Contemporary Visual Expressions

Introduction

The Black American artist in the 20th century occupies a unique position in the history of American art. His sensibility about his African past always remains before him, while much of his artistry is influenced by the distinct patterns of culture that living in mainstream American society has fostered. He is simultaneously inside artist and outside observer of his contemporary environment. As an insider, he is genuine American, and follows the Western ways of making art, as opposed to the African artist or artisan whose work—traditionally religious or functional—more directly serves his community.

As an outsider he is seldom privy to or a participant in the intricate systems within the white male dominated art worlds which, at least in principle, have heretofore provided the white American artist more chance at the vital support system of mainstream academic training and employment, museum and gallery shows, media promotion, and widespread patronage. Although the image of the impoverished struggling artist is frequently apt regardless of ethnic background, the Black artist has been more likely to find himself working under poor conditions, and to find the only hospitable exhibit space to be that offered by local schools and churches and the often meager facilities of predominately Black colleges in the South.

The Black American artist also continues to be buffeted by the conflicting and somewhat patronizing arguments put forth by critics, gallery directors, foundations, and even by each other. It is expected that for commercial success he must produce Europeanized art. However, since he is distinctly different from the white majority of American artists, it is also expected that he should ignore mainstream influences and turn out only primitive and naive works that reflect his African roots.

Working from both inside and outside, an "unbroken circle" of pioneering Black artists, especially in the '20s, sought to create a climate of acceptance for their work, not only in the major art centers like New York, but within their own communities throughout the nation. Their legacy of concern for the positive definition of a Black aesthetic, which took into account the wealth of images abounding within their own neighborhoods and cultures, as well as the legacy of the iconography of African art, surfaced in the art of the period.

Despite that climate of acceptance Black American artists have not reached self-sufficiency in the 1980s. They remain dependent upon the cooperation of fellow artists from the majority culture and those institutions that provide traditional services via corporate investment, museum purchases, and municipal support to present and promote their work.

Yet while the goal of Black American artists may have been to improve their lot in life through mainstream participation in the public art centers of the nation, nonetheless, they have usually enjoyed the sense of brotherhood and mutual support found among other artists (Black and white), and taken pride in the establishment of institutions within the Black community such as Kenkeleba House, the Visions Foundation, and the Anacostia Museum—the latter two associated with the Smithsonian Institution—which have provided the services an enlightened culture needs to sustain creative work. Much has been gained in matters of organizational ownership of facilities that serve as alternative spaces where the business of art can be conducted in a caring atmosphere. It is this which continues the important tradition of encouraging the unity of many artists working together for the good of art and for human understanding.

And all along, within the limits of their situations, individual Black American artists have found ways to continue creating their unique art and sharing it not only within their own circles but in the larger multi-ethnic communities beyond.

Contemporary Visual Expressions presents the work of Washington artists Sam Gilliam, Martha Jackson-Jarvis, and Keith Morrison, and guest artist William T. Williams of New York City. It proudly serves as the inaugural exhibition for the newly constructed gallery space in the new home of the Anacostia Museum. As such it is by far the most ambitious art exhibition in the museum's history.

Contemporary Visual Expressions introduces some of the wider cultural dimensions found in contemporary abstract painting, symbolism within the Afro-Caribbean and Afro-American religious traditions in art, along with three-dimensional visual forms that have derived their sustenance from the folk idioms and cultural customs that emerge from the Black Experience.

This exhibition does not present itself thematically, nor does it represent all the myriad approaches with which these individual artists experiment. But their works presented here do represent the soul of their urban environments of Washington, D.C., and New York City, and transform events and ideas to enliven our artistic sensibilities and contribute to our own understanding and development.

That such an exhibition, which is multimedia as presented and interdisciplinary in its approach to form, has come about, is due, in the main, to the generous spirit of artist Sam Gilliam, always a leader in promoting the work of his peers and that of younger Black artists. When John Kinard, director of the museum, offered a solo exhibition to Gilliam, his response was immediate, clearly stated, and specific in its generosity: "I will accept your offer to exhibit providing I am permitted to invite other artists to share this experience." Kinard agreed, and *Contemporary Visual Expressions* is now a reality.

This exhibition further attests to the prominent position maintained by the Anacostia Museum as being, in the words of Gilliam, ". . . that gem in the other city across the river," the preeminent institution in the city of Washington in bringing to the public the major creative statements that highlight Afro-American material and visual culture.

Sam Gilliam

Figure 7. Sam Gilliam

I am continually amazed to read the rave reviews on exhibitions of Sam Gilliam's work and find that there is only casual reference to the fact that he is Black—a Black artist in whose veins the creative blood of Africa still flows. America's obsession with race, as well as the negative connotation that mere mention of the word "black" conjures up, is unsettling. Who could, for that matter miss the strength and beauty of Gilliam's Blackness? Is it really as invisible as Ralph Ellison wrote? Physically, I think not. Majestic in appearance and nobly fitting the classic description of an Oba, Gilliam's six-feet three-inch frame is as telling about who he is as is his art. I marvel not at the fact of quality a Black man is able to bring to abstract painting, but at the notion that so few people see these handsome works of art for what they really are: visual expressions equivalent to jazz, blues, gospel, and all of the highly improvisational forms with which Black Americans have richly rewarded the artistic sensibilities of millions in the Western world.

So Gilliam is in many ways a bluesman. He is a farmer of the untilled "bottoms" of rich sonorous soil refined and polished to visual perfection. His art sings the blues that were blue before Picasso knew that African art contained a blues formula, or even before the Cubist and modernist experimenters bothered to examine the shrines of Gilliam's African

ancestors, and once having been informed, then "invented" assemblages and installations. So I caution the viewer; "do not go gently into that good night" of Gilliam's artistic statement hoping to find only a second-generation Washington Color Painter or an abstractionist preoccupied with Euclidian geometry and expressionist and neo-plastic patterns. There is in the words of the untutored bluesman "more to be seen there than what meets the eye" in Gilliam's art. Here one sees the raw account of impromptu inventiveness associated with change and the physical reaction one makes of it in the visual world.

Gilliam, who was born in Tupelo, Mississippi, in 1933, has consciously moved his art along the dusty roads of the South, following the flow of rivers that meet and move on. In 1951 he ventured north to Louisville, Kentucky, where he studied art in what was one of the first places in the South where Blacks and whites mingled together peacefully in the studios of able painters at the University of Louisville.

A decade later, in 1961, Gilliam brought to Washington, D.C., a sound background in figure painting, a style he would adhere to until around 1963. Even then, Gilliam showed a recognized sophistication of artistry with which the average painter would have felt comfortable. Not so for Gilliam. He looked within himself, consulted often with the "Black Heads of State" in Washington art—namely, James V. Herring, James A. Porter, and Alma Thomas—at the same time building a lasting alliance with members of the Washington Color Painters for dialogue and support. While it is true that Gilliam absorbed the magic of the colorist formula and found his work modestly informed by it, nevertheless, his sensitive look to the future saw beyond the liquid, flowing, and often circular motifs color painting offered. Gilliam kept in reserve many sources on which he could draw for inspiration. His own childhood experiences of grow-

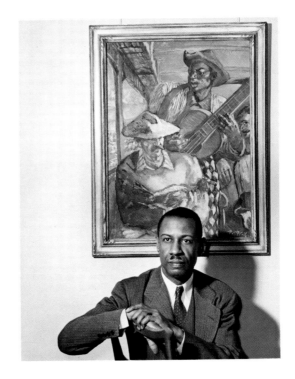

Figure 8. Professor James A. Porter. Courtesy Dr. Dorothy Porter-Wesley.

ing up in racially segregated Mississippi offered an untapped source for seeing the raw core of Black Southern life. Professor Ulfert Wilkie had exposed him to the best of Black African sculpture in his teachings at the University of Louisville, and in Washington, Gilliam for the first time settled into the company of professional Black artists who took their calling in art seriously. His work was less aligned with the art of Kenneth Noland and Morris Louis than with that of Afro-American artists Mel Edwards, William T. Williams, Joe Overstreet, and Al Loving, some of whom had relied heavily on the improvisational character of African textiles as well as the encrusted surfaces of African sculpture to inform their art. The innovative process which Gilliam brought to painting in the early 1960s—that of freeing the canvas of stretchers and allowing

it to become a free-flowing draped-like sculpture—is closely linked to his keen observation of African textiles. Working a few years ahead of Christo, whose unconventional wrappings caught the critical eye of the nation, Gilliam created canvases that should be credited as being among the major innovations to have occurred in modern painting.

As a student under Morris Louis's tutelage at Howard University in the early 1950s, I vividly recall Louis standing by quietly, giving a wide word of approval for every nonobjective stroke I placed on the canvas. He never pointed me to sources and references for my journey into the nonfigurative world beyond the studio. He exuded the kindness of a gentle man, delighted with the notion that his approach to the teaching of painting had fallen on welcoming ears. Just as I had, Gilliam himself greatly admired Noland's and Louis's willingness to work with young Black artists, but he was also acutely aware that these colorist masters had been graciously helped along the way to fame by the Barnett Aden Gallery, Washington's most important Black gallery of the century.

Gilliam's sources are self-evident. His wellspring of forms is inspired by the mythology of African art, abstractly rendered in a way that manifests itself in the rugged and often raked surfaces of his paintings. Diatonic patterns of color shimmer, as in ghostly appearances, on and off surfaces that are often red-hot from a saturation of cadmium reds, warm pinks, and cobalt violets in an orchestration that can only be described as Black. If you do not believe my chauvinistic claim to Gilliam's color choices as Black—then go to Harlem and walk casually up 125th Street between 5th and Lenox avenues, and observe with care, the clothing and body language of the people. Or in Northwest Washington, go to 7th and T streets or 14th and U streets near Gilliam's studio, and watch the myriad display of colors worn by people who are confident of

their aesthetic taste without societal approval. The results will be the same: a personalized mixing of color combinations knowing no age limitations nor color compromise. These color sources from the ordinary people in the Black community have inspired Black artists in other communities such as Chicago where the AfriCobra artists worked.

But color is not all that Gilliam's art is about. His art annexes ancestral forms such as the tie-dye process of African textiles and the roughly textured surfaces found in the encrusted figure sculptures, mislabeled African fetishes, signaling well-planned color coordinates and responses. The mildly hot or cool jazz tonality that is coded in chromatic stages in Gilliam's work is complimentary to the structural way he paints: he cuts apart and pieces together as though he were building an architectural edifice. The crescendo of color culminates in the drama these works present. Colors explode over large surfaces like fireworks, reminiscent of a celebration of an emotional ending, based on events remembered.

Indeed, many such events and incidents have made a lasting impression on the artist and his treatment of form. The drama and energy centering around the death of Black civil rights leader Dr. Martin Luther King, Jr., in 1968 deeply affected Gilliam. Immediately thereafter, he created a series of paintings that provided a new direction in his work. These paintings move away from the sculptural and more Gothic—horizontal forms that were often draped and unstretched canvasses—to a more static and conventionally spatial idea. Some of the works of that period seem to lay bare a soulful response which builds upon emotion, psychological quietude, and tranquility of mind. *A Warmth, A Lightness, A Glow and Then*, 1969, is a canvas from this period, 9 feet high and 25 feet long (figure 9). Moving in four parts from a small format to a larger one in each unit is a decided characteristic of Gilliam's work of this period.

The historical fact of Dr. King's death brought home to Gilliam more than anything else that he was a Black artist, shut out from the inner circle of things, so to speak. He would have to earn his stripes in a most convincing way if ever his art was to take its rightful place in American culture. Not only did he discover that he was an outsider to the white art establishment but also that he was two times removed from the center of things by being a Black abstract artist. He had to ask himself the serious question, What does one do under these circumstances? Does one stop painting, or wait for acceptance? His immediate response was an emphatic NO! One moves on, as stated in the Negro hymn:

. . . there is a balm in Gilead,
to make the wounded whole.
There is a balm in Gilead,
to soothe the sin sick soul.

The answer came in knowing that an important resource in the Black community had not been tapped. Gilliam, along with sculptor Mel Edwards and Bill Williams, neither of whom turned directly to figural or racial idioms as salient features of their work in the 1960s, began organizing their own exhibitions. They met from time to time in each others' studios, first in New York City, then in Washington, D.C., at College Art Association meetings in Chicago, Boston, Philadelphia, and Los Angeles, where they aired their concerns with other Black artists across the nation. They began by organizing shows at Black galleries, colleges, and universities—Morgan State, Howard and Fisk universities, and The Studio

Figure 9. Sam Gilliam, *A Warmth, A Lightness, A Glow and Then,* 1969, acrylic on canvas, 9′ x 25′. Courtesy of the artist.

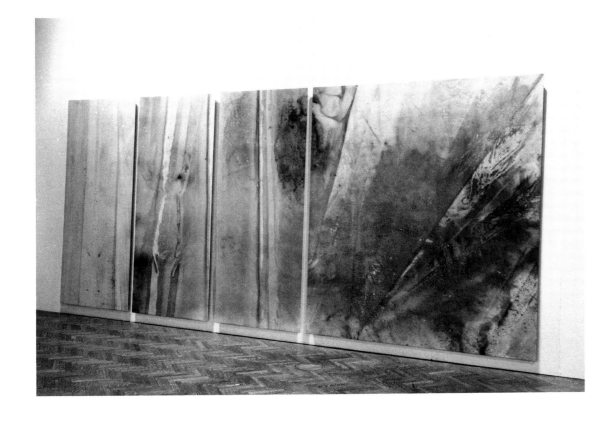

Museum in Harlem among many. Their art was received enthusiastically by Black viewers. The idea paid off. Soon large public and private institutions such as the Wadsworth Atheneum, the Albany Institute of Art, and other well-known mainstream institutions requested exhibitions of their work. These artists would be the first to admit that their goal was not simply to show their work in white museums, but to provide a way of getting works before a larger public, always a paramount goal of the artist.

In many ways, this small group of artists, strengthened by the support of Richard Hunt, John Dowell, and others of their generation, was reviving an important tradition that had existed among Black artists of the Harlem Renaissance and their immediate predecessors who too had few places to show their work. They were moving forward in the spirit of those pioneering souls such as James V. Herring of Howard University Department of Art and Alonzo J. Aden, director of the Barnett Aden Gallery. Aden also founded the College Art Service in 1943 in Washington, D.C. to promote the exhibition of works by Black artists. The College Art Service had received assistance from the Carnegie Foundation, the Harmon Foundation, and the College Art Association of America in its enlightened endeavor to promote what was then called Negro Art. This historical lineage was fresh in their minds.

Gilliam had the good fortune to live in Washington, D.C., at the right historical moment. He often conferred with James V. Herring about plans for his art and that of his fellow artists. Herring was forthright in advising Gilliam to "strive to engineer his own life" and not be wholly dependent upon the will of others. Herring emphasized the need for certain archival institutions where Black artists could see their own work in relation to the work of other Black masters such as Robert S. Duncanson, Henry O. Tanner, and Aaron Douglas. "Record keeping," he advised, "was as much the responsibility of the artists as that of the archivist." This, Herring advised, ascertained for the record "a Black point of view" and assured accurate record keeping.

In seeing the many dimensions of the man, one realizes how important it was that Sam Gilliam did not come to the Washington art scene neatly packaged and ready to be absorbed into the system as a token Black artist. Yet, after all, doesn't each city have one? And will they even permit more than one at a time and in one place? This kind of parochial thinking did not hinder Gilliam. He is a man of his own calling, and, more specifically, he is a man of his own making. He has helped to chronicle his own achievements by moving at the pace of one step at a time. He fought in places where the battle is not given over to swiftness or strength but to knowing and making significant creative forms. He learned to endure the insults of mediocrity which often come from those less creatively embodied and grossly misinformed about his creative accomplishments. Although he looms high as the most innovative painter, the very best that Washington has to offer, Gilliam is still regarded by the mainstream art establishment as a "black artist," or someone to be avoided. A "black artist," in establishment terms, means, a person, "not one of us," to whom white institutions owe nothing other than an occasional glance.

While I do not wish to dwell upon the overspent subject of what is a Black artist, in defining Gilliam's contribution to *Contemporary Visual Expressions*, indeed, one does confirm that he is a Black artist or, more importantly, a Black person whose artistic sources are informed by his own psyche and play a vital role in his own artistry. He is not just "an artist who happens to be Black." And I would hasten to say that figural imagery has little to do with my thesis here. Instead, it is the state of being,

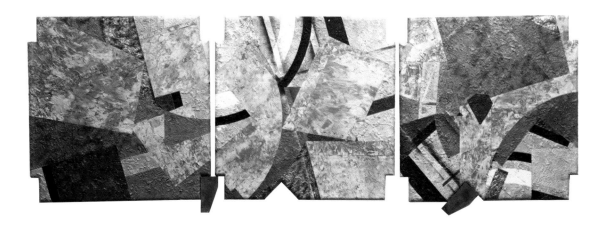

of knowing and doing that plants Gilliam firmly into a Black heritable posture. He knows by action and deed that he remains on the outside of majority culture.

Perhaps more than anything else, Gilliam has immeasurably gained his ends by having to be hard-nosed in his approach to art. He may have taken blows that came from society but he has turned these experiences into positive sources on which to draw. And in drawing from these sources, the artist often graphically makes and remakes a canvas by placing geometrically-charged pieces of a painting out of range of its original space. This jazzlike process of creating the harmony and tonality of a given work by rearranging Euclidian shapes out of sync with each other has come to be looked upon as a special invention of this artist. It works well as process and statement for Gilliam. As process, it shows the direct work of his own hands, manipulating surfaces and establishing for purposes of contrast, those spatial relations that metaphorically and symbiotically carry the weight of a colorful idea. As statement there are the solid interaction and interplay of forms that take place in this exchange process. The cutaway spaces from a square shape, the addition of a metal piece, as occurs in the *D* paintings series and in *Helix Composition*, are a vital part of the process

Figure 10. Sam Gilliam, *Helix Composition*, 1982, acrylic on canvas, 60″ x 180″. Courtesy of the artist.

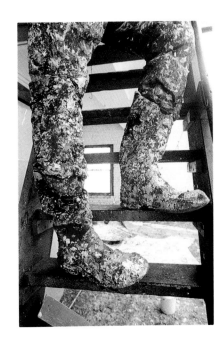

Figure 11. The artist's work boots

that Gilliam uses to ensure drama and formal movement in a work of art (figure 10). The drama of these works, in an attempt to get the viewer from one plane to another in the composition, goes hand-in-hand with the act of establishing a sound regard for design and spatial purpose with a given subject.

In describing how he moves forms on and off the canvas, for example, from the floor to a wall, Gilliam concisely states the importance of texture in his painting. He further explains how his painting has, over the years, vacillated between a two-dimensional format and a sculptural presence (*Saga*, plate 1). He explores the importance of color, texture, and pattern in these works for reasons that add to their import as major modernist statements, but also ". . . because that was the fabric of Africa that we dreamt and recreated." This statement has specific bearing on how Gilliam sees himself following in the tradition of older Black American artists such as Augusta Savage, Aaron Douglas, Hale Woodruff, Jacob Lawrence, and Romare Bearden, all of whom inspired his generation. He notes that these artists did not have to force abstraction into

their work: "It had always been there." Like Alain Locke, Gilliam recognized these artists as the rightful inheritors of the African continuum in America.

Sam Gilliam speaks of a seasoned cast of younger artists, of and nearing his own generation, in the Washington area, who have been part of that community of Black artists he had longed to meet in Louisville before he arrived in the nation's capital. He observed that such artists as Lou Stovall, Bill Taylor, Sylvia Snowden, Leo Robinson, Lloyd McNeil, Yvonne Pickering Carter, Kenneth Young, and Carroll Sockwell are among those who know the Washington art scene for the good and bad things it has to offer. Certainly, for years they have been among the ranks of those who have struggled to keep their art alive in a community where support is not always forthcoming. Gilliam remains in the ranks of his peers a creative artist of great skill. But he is also highly regarded as a person who uses his art to reach out to help others. Many young emerging artists will attest to his generosity in this regard as will his artist colleagues in *Contemporary Visual Expressions*.

Martha Jackson-Jarvis

Martha Jackson-Jarvis spends a great deal of time sorting out mosaiclike pieces of fired and glazed clay. She will then embed these bits into her ceramic sculptures—a ritualistic process which in turn sorts her out as a person unique to the Washington art experience, indeed, to that of the nation.

Even as she works, a spiritual sorting is also occurring. She emphasizes the amount of time spent sorting and making sense out of the orchestration through which she must go when she puts together a symphony of forms that personally documents aspects of her own spirit. Her art concerns the power of a given form to transform itself, as in passing on information and bits of her personal life in the narrative.

Now a devoted young wife and mother living in the nation's capital, Jackson-Jarvis's roots go back to the rural South, and to the family home in Lynchburg, Virginia, where she was born in 1952. There she lived close to nature and early on experienced the joys of modeling clay.

"Clay," she says, "is something I grew up around and played with each time I went to the spring."

Her work, she feels, is never a final statement about herself or her experience. Rather, it expresses the narrative in life metaphorically, in the manner that a stream meanders

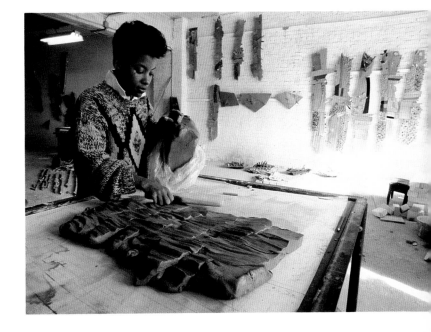

Figure 12. Martha Jackson-Jarvis

through the hill country: as it runs, it widens along the way, picking up the trace elements in the soil.

Often her work takes the form of a fragmented world where consecutive images convey the magic that happens when, under the spell of fire, clay hardens and is no longer nebulous particles of dust or mud. She aligns one form upon another, creating the effect of stelae in an African burial ground. In these stela-like forms, bits of crockery embedded in the surface of her work supplant the brushwork these forms would display if they were canvases.

Jackson-Jarvis's works reminded me of particular experiences I hold dear from my own childhood. When I was no more than four, on Friday evenings, my Great-aunt Sissy used to take me along to her husband's gravesite in the town of Eatonton, Georgia, where I was born. But before we set out, she would first take crepe paper—red, pink, yellow, sometimes blue—and fashion roses, tulips, and frilly chrysanthemums. These she would arrange in a tin can, and also would gather up white sand, colored glass, bits of pottery, and food on a plate. The plate was always a broken one—a symbol of the severance of soul from body, or perhaps a reality of our economic situation. All these she placed on her husband's grave.

I grew up thinking that everyone observed this ritual—only to find out later that I was experiencing something peculiar to the ancestral rites of some African Americans. Yet not until I reached maturity did I fully understand what was taking place.

Imagine how excited I was, then, fifty years later, as I sat talking with Martha Jackson-Jarvis and her youthful-looking mother, and listened to the already incredibly gifted artist reminisce about accompanying her maternal grandmother to the spring on the outskirts of Lynchburg, Virginia. Here her grandmother would find the right kind of white clay for certain family rituals. She also took broken plates and bits of pottery to and from the gravesites of other relatives. From time to time, Jackson-Jarvis now herself acquires pieces of broken pottery at the homestead to insert into her own clay art works. I listened, while she, in tears, told of this constant connection between her past and present. I thought about the vitality of family customs, the vital role of women in promoting Black family traditions, and the celebration of life and death her art recounts, and I felt suffused with new spiritual awareness. It was a historical creative moment unto itself.

Though Jackson-Jarvis left Lynchburg for Philadelphia and Washington, where she acquired much of her formal training, everywhere she took with her her formula for preserving a highly cherished past. And on returning home more recently to attend the funeral of her beloved grandmother, seeing the body committed to Mother Earth for eternity, the artist was reminded of that ever-present source for her art—clay—and also recognized the sacred spell it casts upon those who walk over it daily. She turned her thoughts to the spiritual regeneration of life and those forces that come from that veil of dust. Mud—layers of it—affix in time and space the wandering souls of ancestors, bound only by the indelible spirits they leave behind.

One experiences the magic of a mythic transformation in Jackson-Jarvis's work. The ancient mysteries of clay becoming solid rock take place before one's eyes, and new universal forms are born emanating from that wellspring of magic and myth where imagination and belief blend into one level of reality. The honesty of these forms overcomes their casual placement in a given installation and "stylizes" them as a contemporary visual expression full of mythic qualities.

Physically, Martha Jackson-Jarvis is a small woman. But her artistic spirit towers over the tallest among us. She is soft-spoken, genteel, and polite without the accord of looking like a

Black debutante. At first glance one notices her straightforward gait: she moves with confidence, as if actively directing each poised movement to a place which helps to make her art extend from herself but always seem adjacent. Jackson-Jarvis creates the active accent that clay alone has the power to mold. Her art seems both autobiographical and futuristic. She somehow manages to assuage the palate of those who want to see bits and pieces of themselves and their own past woven in and out of a living metaphor—an unending puzzle of pieces of personal memorabilia reflecting the time and space of her own life firmly held in place by that familiar source—Earth. For it is this broad field of clay, glazes, slips, and mosaics that enhances the large chunks of bisque that form an icon in Jackson-Jarvis's work that we long to experience by sight and touch.

Jackson-Jarvis's art compels her to continue going to the spring even in an urban ghetto where she must shut herself off from the sounds and smells of the countryside in order to create her work.

One immediately senses the clarity with which the artist works. Upon visiting her spacious second-floor studio at 1467 P Street, Northwest, in Washington, one is enveloped by a delightful experience in visual literacy. There, the artist displays several walls, one thirty feet long, of clay works, bisqued, slipped, glazed, and fired to perfection, filled with exciting free forms that move upward from the floor as though they may soar into space were it not for the level of the tin-impressed roof looming overhead. One sees an enormous outpouring of genius bound only by the limits of one's imagination. Large and small ceramic-tile-like forms float freely in adjacent patterns that recall a mosaic-type sidewalk in a Cesarean village. Earth colors such as siennas, ochres, and umbers wind their orderly way through an outcropping of tones and valves that seem magical. Brilliant cad-

mium reds, cobalt violets and blues, viridian greens and golden yellows of a Gothic stained-glass window peak through here and there in mosaic form. These colorful yet subtle forms are anchored in organic shapes that intone earthliness. Basic to this formula of successful composition is the right use of materials, shapes, and colors in a formal way.

There is no doubt in this writer's mind about the soundness and mastery with which Martha Jackson-Jarvis creates these startling compositions. She pulls the viewer into a composition by paving a narrow walkway leading to a multiplicity of directions—up a wall, around a corner, and sometimes through an elaborate opening. In these works, the mind is always anticipating one surprise after another—as one threads through a maze of contemporary forms that create a whimsical labyrinth of rustic pleasure inspired by Earth, whose unending sources of malleable clay is the artist's wellspring. These marvelous transformations take place in Jackson-Jarvis's work. Earth is the literal substance from which the forms in her earlier works, such as the *Legacy of the Matriarch* series, derived their ground and solid quality (figure 13). And from that series, which dominated Jackson-Jarvis's walls thematically from 1983 thrugh 1985, new forms such as *Path of the Avatar* have flowed.

The *Legacy of the Matriarch* series was filled with what the artist describes as "aspects of documentation, very personal in nature," which very often moved from that which was worldly in nature to other levels of reality—often those of the spirit. Her new series of works, entitled *Path of the Avatar* introduces us to other worlds, extraterrestrially felt and composed of a multiplicity of forms that start with a base of clay shapes, often abstract and unevenly crafted (plate 2). These pieces are enhanced by an addition of materials, such as prefabricated mosaics, found objects, old pieces of dishware, and personal bits of family

31

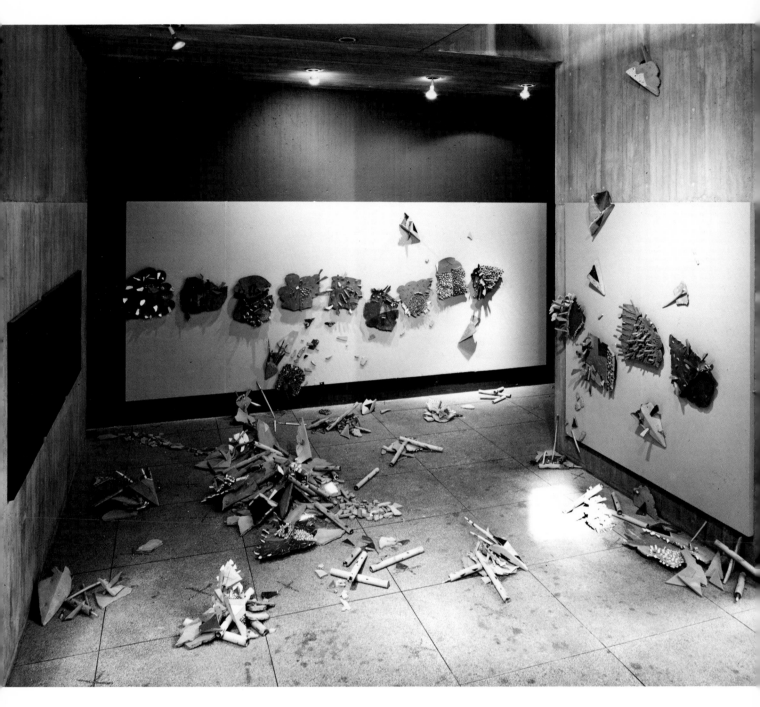

Figure 13. Martha Jackson-Jarvis, *Legacy of a Matriarch/Notes on Death and Dying*, 1986; room size, 15′ x 20′ wide, installation at Everson Museum, Syracuse, New York.

crockery. They serve to bring certain autobiographical aspects of the artist's life into focus. The impressionable dent made by these objects on the clay registers, in a symbolic way, the artist's early childhood memories. She is busy cleaning up the neighborhood, so to speak, placing bits and pieces of history together, chronologically and culturally, recycling into her own life the cherished rituals that are a continuum of the African and Afro-American cultural legacy.

Regarding art inspired by ritual, Jackson-Jarvis speaks of the serious line of communication art is capable of having when the maker is in tune with the environment and does not take for granted the power of forms to transmit cultural ideas. Though we lack the pure knowledge of how it was used in our African past, the ritual of using clay and bits of broken pottery at gravesites for decoration has been studied and observed among African American communities in Georgia, Alabama, South Carolina, North Carolina, and Virginia, to mention only a few. So when we examine the busy format of clay columns created by bits of broken crockery, handmade mosaics, and large glazed free-form pieces of ceramics in Jackson-Jarvis's work, it is not there within the context of a dream. Rather, it has a heritable base stemming from the artist's recalling, re-creating, and regaining a hold on her own cultural history. She explains that her grandparents ate from plates that are now fragmented and physically in the ground. She, like an archaeologist, has searched her childhood environment, found bits and pieces of these treasures of a given time period, and gave them meaning beyond the ordinary. But equally important in this assemblage of pieces of a family's personal history is the genesis of forms that speak eloquently of a statement grounded in a language of contemporary visual expressions. Largely autobiographical, the new works that have been created for *Contem-*

porary Visual Expressions represent a balanced continuum within the Black Experience.

The constant springs or refreshing artesian wells are vital to the recharging experience Jackson-Jarvis undergoes from time to time to replenish ideas and create new forms. The journey to the spring to acquire the necessary clay forms, glazes, and slips is like going to the river. The flow of ideas in this heritable lineage is like the flow of the river, ever-moving fresh from the sources within Earth. Metaphorically, the spread of clay ideas flowing up the wall from the floor skyward is representative of the crossover that the clay makes from a liquid nonpermanent state to a place of final solidity.

The artist works her way through this symbolic journey, concentrating on the long and narrow spaces of a floor from which the creative phoenix will rise from the fire of the kiln. Her method seems to cause the clay to imbue itself as in a living place in the hierarchy of forms. The answer is a response to symbolic feeling—almost never image oriented, but spiritually shaped by the rhythm of spaces and movement around forms, around whole pieces, erasing the ambiguity of space. The artist employs this in a call-and-response format similar to the way a Black gospel choir follows the lead of its call soloist. In such a fashion, an entire wall is turned into an abstract icon highly experienced in soulful mood.

The floor and the wall are environmentally vital negative and positive space indicators in Jackson-Jarvis's clay sculptures. Beyond the centering power the solid spaces enjoy in these floor-to-wall works, one can find an exact yet playful way of fitting large and small forms together in a manner that encourages organic unity of the whole. Some of the smaller clay components, which are separate and apart from the larger wall pieces, could actually function alone as individual works of

art. But they are meant to be seen in the context of an entire space which makes use of a fragmented wall.

These works function as an environment and as installations become more lively with people milling around and into their space. It is then that they change from when we see them void of the human element. Though totally different in physical format and appearance, these sculptural works are closer to African art, that is, in motion and ceremonial use, than they are to totems and sculpture in the round. Bulging forms with protruding sticklike objects (all made of clay) pull the viewer in and out of spaces that require close inspection. The method is like musical saturation, where individual sounds are represented by subtle changes, here in color keys and tactile surfaces.

The ancestral remnants of Jackson-Jarvis's historical past, be it African or Afro-American, are soundly registered in the quiet but abstractly treated forms that emanate from a wellspring of magical and mythical forms—all of which come alive and have consummative meaning in the ceramic sculptures that comprise the *Path of the Avatar* series.

The lively forms that Martha Jackson-Jarvis creates from clay are a living testimony to her skillful mastery of a sculptural process often associated with the academic tradition of modeling. She has individualized the process and bestowed upon it an artistic dignity leaving her without many peers. This she has done by going to the source—Mother Earth—whose clay provides our nourishment as well as our aesthetic play. It is in the latter that Jackson-Jarvis has chosen to leave her imprint, poetically rendered to reflect the joy of her own soul. And it is through her own mastery of this underappreciated medium that we enjoy a larger understanding of the beauty of the most common of all earthly elements, clay, that looming chunk of matter which mirrors that final self, at home, asleep, and at peace.

Keith Morrison

Keith Morrison has determined the significant role the ancestral arts of Africa hold for him. After studying principles of Western art, he quickly returned to Africa's great wellspring of ideas, via both the transformed iconography of his native Jamaica and the adopted principles of Afro-American culture. His discerning eye absorbs and builds upon the immediate strengths of the ethnic theme, the myths and legends of his own childhood.

As artist and scholar, he can be closely linked with an important lineage in Afro-American art, the tradition of Alain LeRoy Locke and James A. Porter.

As critic and scholar, Morrison is the most articulate spokesman to come to the discipline in the last decade. His enlightened body of writings focuses on the heritable sensibilities of Black artists, without referring to their work as an appendage of white culture.

Morrison the artist stands tall among those who would claim their African ethnicity as beacons of light from which to draw the serious substance of art forms that make universal statements. Here we will focus on Morrison as artist and the sources that nourish his art—true, sources on which Sam Gilliam, Martha Jackson-Jarvis, and William T. Williams draw, but for Morrison with the added dimension of a Caribbean childhood.

Our attention turns first to the Jamaican Ex-

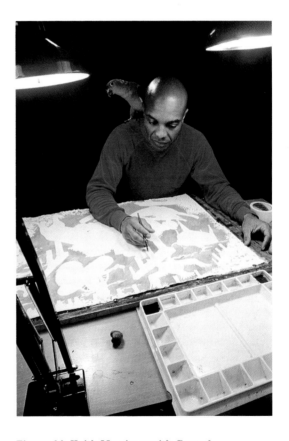

Figure 14. Keith Morrison with Conrad

perience in which Morrison bathed physically and spiritually for his first seventeen years. He was born in 1942 near Kingston, in Linstead, a town noted for its beauty and favorable year-round climate. His was a middle-class rearing, the kind that prepares one for a mastery of traditional Black life accented by certain stylistic adaptations from polite European culture. Jamaica's capital city, Kingston, provided this and much more for the young aspiring artist. Moreover, in this Caribbean society, Black people played significant roles in government, the arts, education, and life in general. Morrison completed courses at the School of Art of the University of Jamaica, West Indies, then enrolled in the Art Institute of Chicago to pursue a master of fine arts degree.

Morrison brought with him to Chicago the patterns and forms of West Indian imagery that he since has successfully woven through his art—both abstract and figurative—over the past thirty years. Initially, he had attempted to blend this imagery into a formal design concept that let abstraction develop without conflict in his work.

"In every case the source of the patterns is a fascination with its emotional and sensual power," Morrison stated in conversation with the author. "This to my mind is not unlike the effect of pattern in African and some Middle Eastern art. This use of pattern is also very much a part of folk art in Jamaica and other parts of South and Central America where I got my first interest in it. Further, I have always liked the 'funky' quality of the patterns of the clothes and decoration of poor people in Jamaica."

But his studies toward the master of fine arts at the Art Institute of Chicago also provided impetus to investigate traditional Western sources and to absorb the genius of their artistry into his own work. The work of Goya impressed him most, especially because the Spanish painter's work vividly portrayed true elements of human drama.

"It is painting about the drama which results from human relationships," Morrison further stated, "rather than the study of composition or problems of form. Goya sees the human drama as tragic, comic, and grotesque at the same time. His vision fascinates me. I do not wish to paint like Goya: after all, his world and mine are very different. However, I feel some spiritual compatibility with his work."

Despite the intellectual stimulus of Chicago, as a graduate student Morrison felt the cultural shocks and sense of isolation which often encompass foreign students in a new land. He missed Jamaica's warmth and openness of society. Now for the first time in his life, he experienced overt racial prejudice, the kind Black Americans had lived with all their lives.

It struck him as odd that there were no Black teachers in the school of art at the Art Institute. He met very few Black artists. American textbooks, he noted, especially art history books, mentioned Black Americans only in the context of slavery. He learned that Blacks were thought to have no historical or cultural roots other than those acquired in the United States.

After finishing graduate school Morrison began a process of re-education: unlearning a great deal of Western art history in order to learn about 19th century Black artists such as Robert S. Duncanson, Edward M. Bannister, Edmonia Lewis, and Henry O. Tanner, and then in the 20th century, Aaron Douglas, Romare Bearden, Augusta Savage, Jacob Lawrence, and Elizabeth Catlett.

It did not take Morrison long to see the richness of Black culture and he quickly began to process and synthesize through his art the merger of the cultures of the African/West Indian and European. As he began to merge these cultures into the format of his work, he also began to incorporate iconographically those metaphors and symbols that carried with them a universal message. He reasoned,

in an American sense, that abstraction was the best way to pursue such goals. In his earlier works, realistic subjects emerged in medium to large canvases that dealt with the maximum use of space as a means of staging people and things on a two-dimensional plane almost abstractly. Yet he observed something missing in his art. Abstraction dominated the work spatially in pattern and design, yet the content Morrison yearned for seemed to lack the richness and color inherent in the art of Jamaican culture. He felt that he had to come to grips with himself artistically, first by recognizing the truth of his artistic sources and then by dealing with the rich strains of his own culture. The result was the developement of a body of work that did not press to make political statements or force his Blackness to be announced in text. Instead, this work expressed the profundity of the man: a Black artist whose sources were rich with myths and narrative accounts of a New World culture that had been greatly informed by the ancient traditions of African life.

So what one sees in the current body of Morrison's work comes into existence through the artist's introspective review of soul and culture. More recently, Morrison has returned to the folklore, religion, and myths of his native Jamaica for thematic ideas to enrich and inform his canvases in the same manner that in Black literature Langston Hughes used the simple ways of Black people to highlight the drama he saw so richly played out in Black American life. Such art, while rising from the basis of a fragmented cultural context because of the complexity of American society, particularly as concerns race, is quickly discernible as not being mainstream. But that is one of Morrison's strengths. By not being mainstream, he has the approval of his culture to draw upon the ordinary. In so doing, he can often laugh about conditions that would upset others; and he can celebrate that which reaches the common understanding of the un-

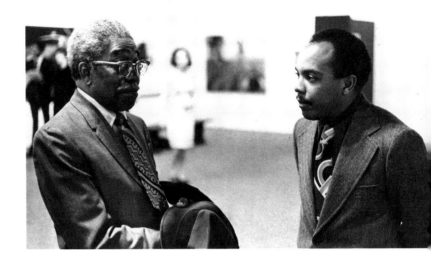

Figure 15. Aaron Douglas, *left,* with Keith Morrison in 1974

tutored observer. Much of what appears complex and puzzling within this cultural matrix is indeed simplistic in its forthrightness in the telling of a story. It is here that we enjoy an Afrocentric sensibility in Morrison's art.

His art is not only Afrocentric in its mythic bearing, as in the way it explores individual space and cultural territory; but it is also Afrocentric in the way it explores the folk culture of urban and rural Jamaica. To a certain extent, his art stands alone on its own cultural turf. (Robert Rauschenberg stood alone when he explored American urban culture through the introduction of pop art idealizing junk and the familiar image. For this he was awarded the accolade of a creative genius of his day.) I ask, is it not important that Black artists look about themselves for their own discoveries in order to make meaningful statements that underline the sources of their cultural turf?

The discoveries applied to cultural turf in music can be equally as inviting as in art: the mythic content that exists in the blues is strictly Black in form, yet it is universal in its descriptive analysis of loneliness, suffering,

hunger, love, and companionship. It is that which is ordinary and simplistic in format which makes it territorial in tonal quality. As original art forms, the blues, Spirituals, Gospel, jazz, and Black folk art stand alone in their rejection of mainstream formula and process, and are alone in their celebration of the ordinary. They are the most original forms of art to emerge in the United States and are Afrocentric rather than Eurocentric in their universality.

Morrison, like Jacob Lawrence and Romare Bearden, and before them, Aaron Douglas and William H. Johnson, examined the richness of Afro-Caribbean and Afro-American cultures, absorbed their strengths, and vowed not to allow his own art to become a footnote to white culture. He works within an established tradition that holds up the image of man to the "the measure of all things." Such a world recognizes the kindred associations of animals and spirits as viable forms from which to remake an art of African vintage. The success of these works is evident in Morrison's paintings in *Contemporary Visual Expressions.*

By returning to the genuine sources of art he grew up with in the West Indies, Morrison all but removes himself from the unsound didactic criticism that needlessly compares the work of a Black artist with that of an artist of European ancestry. It will not be easy to tie Morrison, tail end, to a Julian Schnabel or latter-day expressionists. He does not fit the mold. Morrison's originality goes beyond formalism within Western formula. Indeed, he does observe the academicism of Western painting by providing infinite spatial grounds through which the action of a given subject takes place. But with this visual device, he is able to tell a personal story without the psychological discomfort of abandoning the spirit he brings to painting. He continues to hold the viewer captive in his work by offering an unconstrained sense of freedom and the freshness we experience when looking at walking

canes, "grotesque jugs," and other carved images from within the Black folk art idiom.

We recognize Morrison's attempt to recall the functional aspect of art by making paintings that are important in the humanizing process. His drawing upon functional sources affirms selfhood and thereby strengthens the notion that his art particularizes the Black Experience in a way which connects it positively to the nature and form of the African mind. Here he views the African mind in terms of its originality in the context of Africa and African peoples in the American diaspora. This vision of truth that the African mind has brought to the art of the Western world is refreshing and regenerative. Picasso, Modigliani, and Brancusi were among the first to recognize it. The richness of art of the African diaspora derives from the experiences of Blacks moving westward—hyping the creative context of art with the magic and emotion of Africa, thereby bridging the gap between African and European cultures. Morrison rallies nobly to this challenge, picking up the pieces along the way, and consistently creates a body of work that refers to the subjects other minority artists so often overlook in their quest to enter the mainstream of majority culture art.

Morrison's use of the figure in composition shows his affinity with the paintings of Goya. The figuration in his art is frequently involved with life and death situations. The satire and humor of the good life are revealed by the varied uses of man, dolls, and members of the animal kingdom. His poetic treatment of the theme of life is poignantly enhanced by three recurring themes: the first is characterized by images that show satire and humor, the second concerns death, the third deals with the masquerade or Jonkanu dancers in Jamaica in lifelike situations. Concerning his use of animals and dolls, the artist recently stated to the author, "I often use animals as a symbolic substitute for humans in painting. I also use dolls the same way. Sometimes the animals

are also dolls. As such they are like effigy figures. In addition, I feel they create a sense of unstable reality or of a reality whose meaning is ironic in its transience. I mean that the reality is a real fish at one moment and a toy fish in a bowl the next. It has the effect of being tragic at one moment and comic the next. It also creates the condition of reducing the awesome burdens of human misery to the trivia of dolls and toys—and vice versa."

While life seems the central theme in many of Morrison's canvases, death is often alluded to or acted out in the guise of familiar forms. Here, death is the ultimate response man makes to living. The African mind, from post-slavery days in the Caribbean and in the United States, as in Africa before the coming of the European, was preoccupied with death. The death rites of Africans in Egypt four thousand years ago greatly influenced the twenty-five-hundred-year-old burial rituals of the Yoruba people of West Africa in what is present-day Nigeria. Many of these Yoruba descendents were settled in the New World under the forced migration of slavery. Through various religious and secular rites, slaves kept alive notions of how to prepare for "the good death," be it through religion or service to mankind. While some of Morrison's art comments on Black crime, much of it speaks of the good death. Often he recollects his experiences as a child, going with his grandmother to funerals, wakes, and burial rites. He recalls how African in origin these events seemed, just as Martha Jackson-Jarvis's art recalls her childhood visits to family gravesites in Virginia and the ritual offerings to the dead.

Morrison deals with the theme of death in two distinct ways. In the first, he comments upon the daily hunger and eventual death of thousands of African children while a mostly well-fed world looks on. Death resounds in its ability to rob one of the good life. The artist evokes the social responsibility of all people to help prevent starvation—wherever it occurs. In the second theme, Morrison comments upon death as being the end of the myth. In this case, death is seen as palatable, humorous, and inevitable.

Bones of Africa, for example, is filled with mauve and somber colors in a very abstract way (plate 3). The desert, as in *Echo of a Scream,* is the somber setting for this chilling theme (plate 4). In *Bones,* death in the form of a skeleton is served up in the grand style of the best at fine hotels; silver, mat, and plate lying in two-point perspective are over the thin shadow of the continent of Africa underneath. The bones are the skeletal remains that result from physical death, but they are also the "dry bones" of Biblical literature already connected and waiting to "... hear the Word of the Lord" at the appointed day of Resurrection. The mythic content of death—the subject of relief, and death the "grim reaper" who goes around taking lives—is woven into and out of the composition in a manner that pesents two realities of what dying is about. *Shadow Over Africa* presents two Ibeji figures, Yoruba twin statues, carved to enhance the life or death of twins, on a table mat (plate 7). The male Ibeji is standing, a position indicating that this twin is alive, the other lies over an empty plate, a symbol of death. A snake curls its body in and out of the picture, while all exist within the shadow of a condor, the death bird.

Not all of Morrison's paintings are as explicit as *Bones* and *Shadow Over Africa* in their attempt to portray the mythic presence of Afro-Caribbean and Afro-American subjects in American art. Some are based on the individual aspirations of the artist to put bits and pieces of his own heritage in place without the systematized iconography of Christian art.

In *A Wreath for Udomo,* death as the end of the myth is observed. This work by Morrison refers to the fatal price many African leaders pay so that their countries may be free of

Western colonization and domination (plate 10). A lone trumpeter, with horn and phallus erect, a portrayal of man's distinctly visceral quality, sends forth the potent requiem—the death tune—the last call for a stylishly dressed dead tuxedoed leader who is seen abstractly floating above the ground. His ancient spirit lies below, recounting the lives and deaths of Black leaders in the Western world from Toussaint L'Overture from Haiti to Patrice Lumumba in post-colonial Zaire. The floating body symbolizes the notion that death frees the soul. The mummy underneath is the ancient symbol of death from Egypt and the Lazarus of the New Testament. A circle of Christian crosses enumerates the many deaths Blacks gave in the cause of freedom. A cock crows in the distant space adjacent to an unclaimed halo. The denial of Christ is made real here with the symbolic denial of the right of the Black man's humanity and freedom. The horse and bull figure boldly in Morrison's iconography. Unlike Picasso's bull in *Guerneca,* which represents brute force and power, the bull in *A Wreath for Udomo* is rather tame and provides an aspect of comic relief in the shadow of a docile horse who seems not to know front from rear. One split banana leaf, a bright reminder that all of this action is taking place in the tropics, overlaps a rinceau in the form of a wreath made of purple passion flowers. A Rastafarian priest orchestrates the entire ceremony in the form of a dream.

Again, the concept of the dual levels of reality manifests itself in Morrison's art in a manner similar to the way it appears in the art of Jacob Lawrence. When asked about this analogy, Morrison responded by saying, "a strong part of the tradition of my painting came from Jacob Lawrence. This is especially true of the more abstract works such as *A Wreath for Udomo* and *The Ritual of Death is a Black Tie Affair,* where the space tends to be ambiguous or the forms more flat. However, it is also generally true in terms of the use of contrast-ing color to create special effects and prismatic views. These ideas in my work did not originate upon seeing Lawrence's paintings. They came from seeing the forms of the Jonkanu dancers in Jamaica as a child. However, Lawrence's paintings reinforced and clarified the possibility of using these forms in painting. In this vein, my work also relates to that of Ramare Bearden and David Driskell."

The Ritual of Death is a Black Tie Affair again plays upon humor and satire in a complex setting where on the ninth night of celebration of the death of a loved one all night strange personages sing and dance (plate 5). Here, ghostly forms appear as a two-headed horse, an androgynous person, a serpent, and an undressed corpse in formal attire. The reference is strictly Jamaican in its homage to ghosts (duppies) and its cautious reverence for travel in and out of cemeteries. The death rite in Jamaica parallels, in many ways, the celebrations among Southern Blacks at wakes, watches, or vigils for the dead. But one should not confuse the benign spirit of a duppy with the evil which resulted in violent death as in *Ton Ton Macoute* (plate 9). Dominating this composition is a pair of dark glasses—the kind worn by the secret police of François "Papa Doc" Duvalier's violent Haitian regime—like the scorpion symbolizing death for thousands of Haitians. The dark glasses are blind to justice and hide the real appearance of the criminal. The butterfly symbolizes freedom and peace in the midst of violence.

Life, the central theme in so many of Morrison's canvases, is depicted with much humor and satire. But his humor is often universalized, as it relates to a particular theme, a legend, or folktale. In *River Jordan,* a fearless Black preacher stands at the helm of his boat, decked in colorful regalia befitting an African chief or a prophet David of the Spiritualist Church of Wandering Souls (plate 6). He is commanding souls forward within the gaping mouth of a big paper fish. The imagery revives

the Christian theme of Jonah and the Whale, but it comments satirically upon those who blindly follow leadership representative of a false doctrine. The monster fish is colorful but unreal.

Its teeth threaten, although its mouth is securely locked except for a place held open by the curve of the boat in the upper regions of the fish's jaws. Again, the artist reverted to childhood memories of monster tales sprinkled with the flavor of Christian stories for moral reasons. Inside the jaws of the paper fish a skeletal figure dances as in flight. He is the freest of all on the make-believe journey. The Jordan River symbolizes crossing over waters in life that give setting to a place, in this case, a body of water, in Black religious lore, that lies just beyond life and into death, that must be navigated successfully if one wishes to reach Heaven. The Negro Spiritual intones,

> . . . *Jordan River, I'm bound to cross,*
> *Oh! Oh! Jordan River, I'm bound to cross,*
> *One more wide river to cross*

Satire and humor dominant *Echo of a Scream.* Here the point of reference is again two fish that are equally unreal. Both open wide their mouths to accent their ferocious character. But we are not convinced that they are dangerous. They too represent phases in one's life. Here the fish are out of character, geographically, with their natural environment: they are desert fish. They are the kind that live without water. They remind us of the fish tales or the phallic stories that Lawrence Levine connects with certain elements of Black lore in his book *Black Culture, Black Consciousness.* These works exploit the humor present in the idiomatic expression used by Southern Blacks who do not wish to give a straight answer to a given question: "seems like it was but it wasn't." In fact, these works likewise uphold an old African notion that

there is never altogether one reality with form.

The satire and humor of a work such as *Echo of a Scream* also show that the African mind is inventive in "making do" with what it "comes up against." This concept of satire, the ability to "laugh to keep from crying," is broad in its philosophical implication. And through its convincing form, be it the visual imagery or Morrison, the tonal quality of a blues song, or the Black rhythmic rap to an urban strut, the message often accentuates what is real about a given thing in more than one way, while it remarks upon the humor therein.

Morrison's feeling for myth and ritual as expressed in his art presents itself in several ways. It is fundamentalist in its emotional outpouring of religious and mythic quality. It is likewise extremely Jamaican in the way it reveals the several layers of reality within the image format. The layers of reality in the African and Afro-Caribbean lore, religious symbolism, as well as the magical content in the ten paintings that Morrison has contributed to *Contemporary Visual Expressions* are revelations of the African mind at its best in the New World. Morrison is at his best when completely striking the magical note that lets him draw upon his own Black sources.

William T. Williams

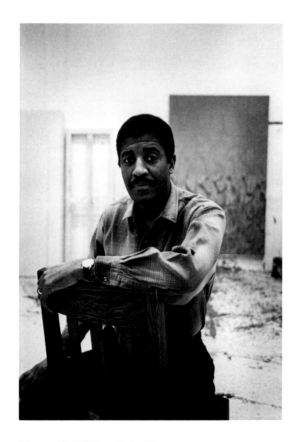

Figure 16. William T. Williams

About two years ago, I was asked to write an essay on the art of William T. Williams for the first major exhibition arranged for his art in his native state of North Carolina. The exhibition, held in May 1985 at the Southeastern Center for Contemporary Art in Winston-Salem, highlighted his works of the years 1974 to 1985. I titled the essay "An Unending Visual Odyssey," as I have been fortunate to see the serial mobility of the artist's development over the past two decades. Williams has undertaken a distinctly unending visual odyssey over the years as he progressively explored more competently and personally the craft of painting in ways that extend immeasurably the varied format of his work.

We will better understand Williams's unending creative journey if we know that his art evolves within abstraction from various sources. First, Williams has coherently pursued, with personal and original achievements, a distinct direction in color-field painting that makes him a pioneer in the movement along with Sam Gilliam, Frank Stella, Kenneth Noland, and Morris Louis. Second, the geometric lineage of evolving forms that appears from time to time in the artist's work developed out of a well-seasoned approach to the understanding of Euclidian principles that are mathematically sound and visually related to the lines of urban architecture.

Third, the artist's articulate search for a means of delivering the visual icons of his own psychic soul has led him to those sources within the Afro-American Experience that val-

fectly lined angular spaces within Williams's work allude to a formula of making which is both rational and magical as delivered. We find the repetition of many lines that both separate one form from another as they conform to the rules of perspective, as well as those which go against the grain of Euclidian principles. In these colorful works, the lines that separate one form from another are always white. And from this meticulous formula for floating layers of color—one on top of another—is born a subtle registration of forms that seems free of the usual starkness of hard-edge painting. This then is the rational aspect of Williams's artistic process.

But Williams's art also invokes the magic of delivery—fooling the eye with geometric planes—as he juxtaposes forms that run in accord with each other concurrently but at the same time seem to dissect the canvas propor-

tionately. In compositional references, such as one finds in *Elbert Jackson L.A.M.F., Part II.,* 1969, Williams uses the angular device of broadening color planes, shifting them around on an entirely painted surface, and convincingly creates a planar illusion that does not exist except in the mind's eye (see figure 18). These forms succeed in fooling the eye to accept the magic of inter-planar relationships that do not always exist physically. More important is the magic of color these forms communicate. One often sees bright reds, from cadmium to vermilion, saturated throughout a canvas that is equally laced with turquoise blue, cobalt violet, and viridian green to create a fantasy of color coding that is reminiscent of popular colors worn by young Blacks for disco and entertainment dress.

The inventiveness of Williams's color coding comes also from the lively sensibilities he brings to art from Afro-American culture and his own search for self-identity. Williams, like Sam Gilliam, was confronted with some of the same decisions that caused his art to be informed by the impact of the Civil Rights Movement, particularly the death of Dr. Martin Luther King, Jr. Williams's art, like that of Gilliam, Mel Edwards, and other Black artists whose works matured in the late 1960s, underwent several metamorphic stages evolving articulately in physical stretches that showed individual growth and an astute awareness of African antecedents. For Gilliam, it was the improvised character of the canvas as draped fabric, stained and blurred with the delightful resonant tone of African textiles. For Edwards, it was the dynamic spirit of steel in its plasticity, as in *Lynch Fragments,* which had the monumental presence of traditional African sculpture without adhering to ceremonial function. And for Williams, it was a careful study of the physical characteristics of paint surfaces as they appear on African masks, one layer of paint on top of another, encrusted, worn, and heavily impastoed to

create a magical impression.

Williams and other Black abstract artists of the 1960s were, in many ways, responding to a long tradition in Afro-American art: that of looking back to the ancestral arts of Africa for inspiration. They recalled the credo of Alain LeRoy Locke, who admonished artists of the Harlem Renaissance to claim their rightful heritage through interpreting African forms and to win for themselves the accolades that European artists such as Picasso, Brancusi, and Modigliani had won. This introspective examination of African art and of the rich untapped sources of Black American culture was a heritable reconnoitering of sorts that excited the imagination of artists of Williams's generation. As abstract artists, they knew that they had to search harder, near and far, to find those ideas and forms that connected their work to the Afro-American continuum. But they knew it to be a necessary task. The outcry for those images by Black artists that reinforced the notion that all Afro-American art must concern itself with literal interpretations of Black history was rampant in the Black community during the 1960s. Just so, many whites came to look upon Afro-American art as being nothing other than that. But Williams found solace in the art of Henry O. Tanner, Aaron Douglas, and Hale Woodruff, for he saw that their art had embraced a modernist and abstract posture in the 1920s. Tanner had been approached by Locke to return to the United States to help found a Negro school of art in the 1920s. Tanner did not agree to follow through with Locke's request. Locke saw Tanner as a modernist whose work embraced the lively cannons of abstraction and Impressionism. Douglas mirrored the taste Locke desired in the new abstraction as he was able to synthesize elements of cubism and by leaning heavily on the iconography of African art, created a formal style which connected his art visually to the ancestral arts of Africa. Woodruff combined the modernist formula of Cé-

zanne with that of drawing from the sources of African sculpture to create images greatly inspired by African art.

The New Negro Movement of the 1920s had once and for all made clear the distinct need for Afro-American artists to articulate the necessary vision of "their own black souls" by fostering a historical tradition in the fine arts among themselves. But the artists of the 1960s were in some ways assimilated into "the system," so to speak, by association, if not by actual acceptance of their art. Williams and other artists of his generation were trained by white artists at white American institutions and had been vested to enter the American mainstream.

Williams is among those artists who made the transition from a pupil in the art schools of the nation—where much time is spent teaching one how to make art from art—to an artist of towering proportions, one who turns to his own life experiences for the sources of his art. He began to focus on the known rich heritable contents of his own psyche. He began to search for a language of form that would convey the message of his personal sensibilities in painting, those arrived at through an introspective creative process. This improvised way of making art would take him away from the act of painting with brushes as usual to a more experimental way of putting paint onto the surfaces of a canvas. This new approach would bring him closer in process to the spirit and form of making a painting the way a jazz musician composes a tune. The full capacity of a given instrument's range, from the imitation of the human voice to the refined technology of brass sound, is what the jazz horn player expects to receive from his instrument. By discarding the brush and reaching for the canvas with his own hands, Williams extends the painterly format of his work beyond the conventional (*A Note to Marcel Proust*, plate 14). This manner of impromptu inventiveness takes place in a very informal way. The artist

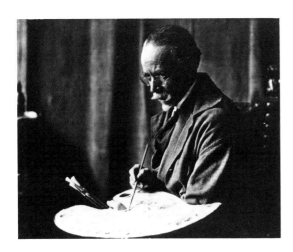

Figure 17. Tanner in Paris in the 1930s.
Courtesy Professor and Mrs. David C. Driskell.

no longer adhers to conventions relating to the color-conscious inventions of his geometric paintings of the 1960s. Instead, large spaces within these paintings have rusticated surfaces or painstakingly calculated palm-of-the-hand-like patterns that are repeated over the entire surface of the canvas. In *Loch Ness,* 1984, a heavy application of paint is revealed on the surface under which many layers of paint have evolved (plate 13).

The figural element in Williams's work manifests itself as a dynamic pattern layered onto the canvas, as though its placement and sculptural appearance were identified with markings on an Ibo or Cross Rivers (Nigerian) mask. In other works, such as *Cobalt II,* 1974, and *Equinox,* 1974–75, from this period, a period characterized by monochromatic/tactile color-field painting, figural elements are not easily discernable (plates 11 and 12). Here, the artist moves away from the direct lineage he previously observed in what was looked upon as hard-edge painting. In the monochromatic paintings that employ an addition of pearlescence powder (a ground sea-shell compound traditionally used as a base in the making of cosmetics), small brush strokes are used to deflect and reflect light, depending upon the angle in which the paintings are seen, and light dances over the entire surface of the canvas. The repetition of geometric patterns below the painted surface in these works connect them to *Elbert Jackson L.A.M.F., Part II.,* 1969, and *Sophia Jackson L.A.M.F.,* 1969, without revealing their direct kinship (figures 18 and 19). The geometric patterns of these subtly painted canvases are barely visible and to be fully appreciated must be seen in a particular lighting arrangement. But there is a formality to these works that relates to nature—that of seeing light shimmer over the surface of water when waves are created by a circular ripple on a pond. The pearlescence powder that Williams uses as an additive to the acrylic paint enlivens the surface of these canvases and adds a positive form of crafting to his art.

In my essay "An Unending Visual Odyssey," I wrote of Williams's exploration of the textural skin of paint, heavily pigmented and rolled onto the canvas, a technique he began in 1978. He relied on the strength of a planned palette that seemed unending in rich resonant appeal. Williams directed his art even further away from the international style of painting and realigned his sights on ideas of color commonly seen in the foliage, fauna, and soil of his native North Carolina. In these paintings, muted and subtle color relationships are established that allude to the beauty of natural pigmentation and its staining power. Also in these works, nature seems veiled through Williams's use of roughly treated surfaces, some fragmented by cracks in the paint—producing a canvas that resembles the outer layer of barren soil in need of precious rain. Here a new poetry of color is established, revealing in its majestic outreach things we are accustomed to seeing. The rusticated bark of pine and oak trees, the smooth speckled cover of dust over the surface of magnolia trees in spring recovering from the winter's kill—all of these

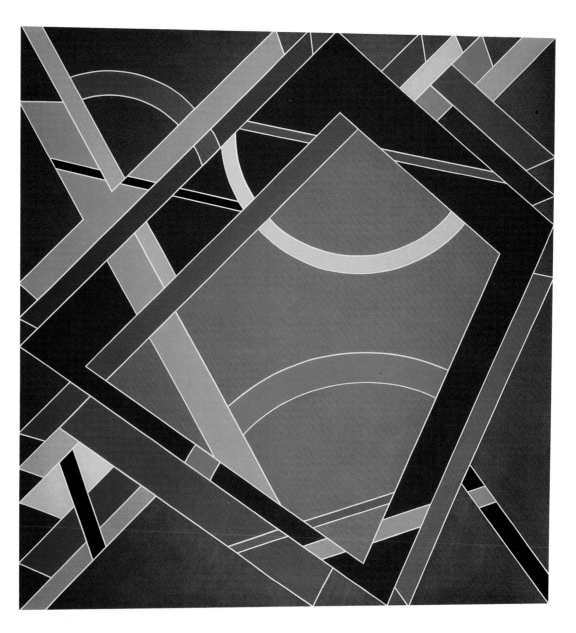

Figure 18. William T. Williams, *Elbert Jackson
L.A.M.F., Part II.*, 1969, synthetic polymer paint
and metallic paint on canvas, 120″ x 120″, Museum
of Modern Art, New York, New York; gift of Carter
Burden, Mr. and Mrs. John R. Jakobson and
Purchase.

Figure 19. William T. Williams, *Sophia Jackson
L.A.M.F.*, 1969, acrylic on canvas, 84″ x 60″, in the
collection of the artist.

46

47

images are born anew in the handsomely crafted surfaces of Williams's paintings. Gently rippling over the canvas plane with accentuated relief, a monochromatic poem is created with color that dances quietly in parts emitting emollient sounds in painted form. Immediately and with corresponding assurance of grandeur, landscape and all of its terraqueous mysteries invade our sense of sight. We are made to stand in awe of the celestial radiance of clouds where none exists and experience the presence of water on totally dry surfaces. The formal statement communicated by these paintings spells out a spiritual definition of the paradisiacal vision commensurate with a new way of interpreting modern landscape. Instead of depicting the physical appearance of things as we see them in the natural order, Williams can be counted on to metaphorically probe, provoke, and personalize art in a manner which establishes invention of process and newness of form simultaneously.

Much of Williams's search for a personal style of expression can be traced to his quest to identify and thereby to validate the heritable sources of his own iconography. The search took him through the history of art where he looked carefully at the visual expressions of European, American, and, more recently, Afro-American cultures. Only in 1977 did Williams travel to Africa. There he saw a less formal way of making art whose purpose is to serve the community. He became more fully informed about how his own art fit into a cultural context that had a totally Black format. In Africa, he noted, the success of a work of art was not bound in any fashion by how critics viewed it. Indeed, Williams had thought all along that the spiritual force of the form and its relevance to the African psyche were what counted. He then sought a way for his own art to mirror this approach to making, certainly in its entirety, a non-Western pursuit of the object. He reasoned that the only way to keep his art valid as an important statement within the African and Afro-American continuum would be to keep it moving forward on a human scale. "Make the very best art that you can make which helps to validate your own civilization," he reasoned, "and you will leave a legacy for others that speaks of the relevance of one's own artistry."

The process of visual catharsis, looking at the roots of one's own culture and redigesting its larger meaning in symbolic terms, has allowed Williams to look always at himself to see if he is carrying excess baggage in art. Thus he is his own best critic and can thereby decide how much of the emotional content of his life is a necessary ingredient in the larger formula of the pursuit of the rational process of creating art that speaks to the heritable sensibilities of one's own psyche.

Color Plates

These color plates of the works in the exhibition are arranged alphabetically by title under the individual artist's name. Dimensions are in feet and inches. Height precedes width precedes depth.

Unless otherwise listed, all works are owned by the individual artist.

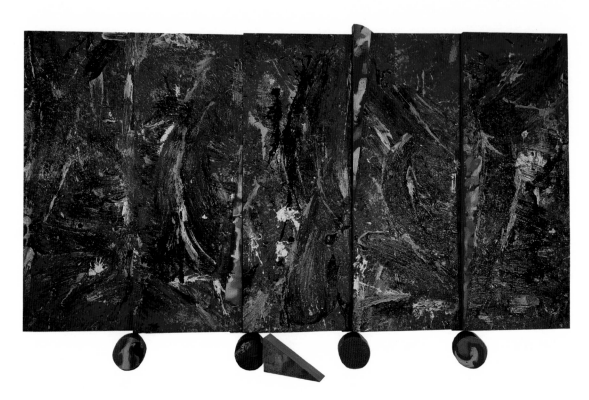

Plate 1. **Sam Gilliam**
Saga 1986
(Cover)
acrylic/canvas, enamel, and acrylic/
aluminum
113″ x 190″ x 8″
Middendorf Gallery, Washington, D.C.

From *Path of the Avatar* Series

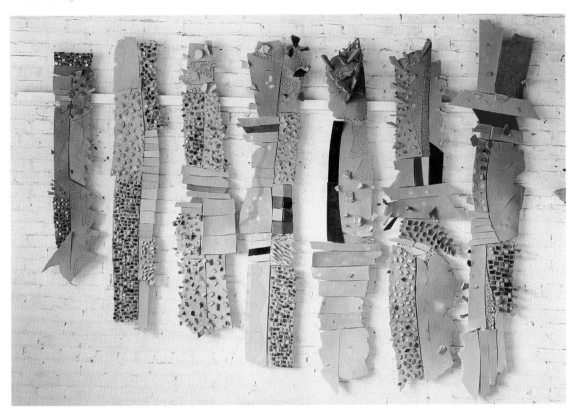

Plate 2. **Martha Jackson-Jarvis**
Path of the Avatar, 1986
Installation

ground mosaic
10′ in diameter

wall sculpture
seven panels
earthenware
6′ x 18″ x 12″

wall sculpture
(not reproduced here)
eight panels
earthenware
4′ x 12″ x 12″

wall sculpture
(not reproduced here)
eight panels
earthenware
6½′ x 3′ x 12″

From *Path of the Avatar* Series

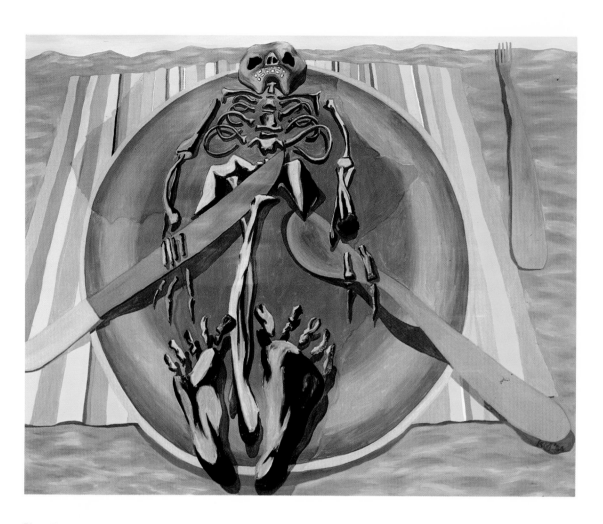

Plate 3. **Keith Morrison**
 Bones of Africa, 1986
 oil on canvas
 48″ x 60″
 Brody's Gallery, Washington, D.C.

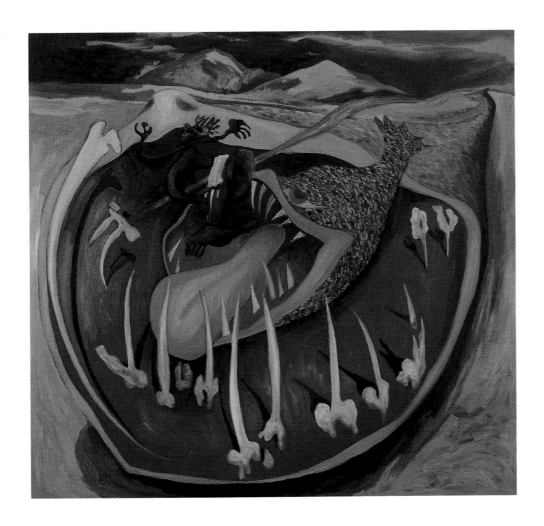

Plate 4. **Keith Morrison**
Echo of a Scream, 1986
oil on canvas
50″ x 54″
Brody's Gallery, Washington, D.C.

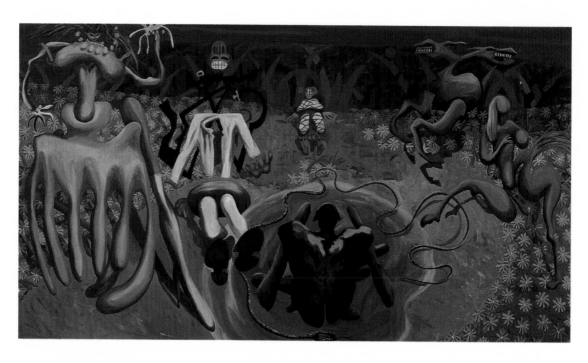

Plate 5. **Keith Morrison**
The Ritual of Death is a Black Tie Affair,
1986
oil on canvas
60″ x 108″
Brody's Gallery, Washington, D.C.

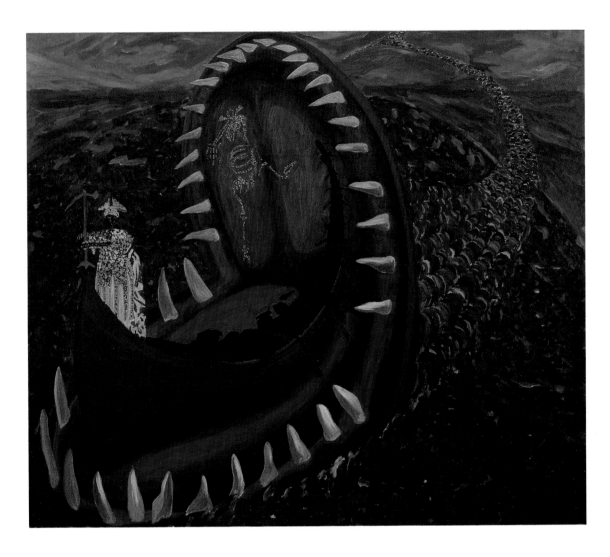

Plate 6. **Keith Morrison**
River Jordan, 1986
oil on canvas
46″ x 54″
Brody's Gallery, Washington, D.C.

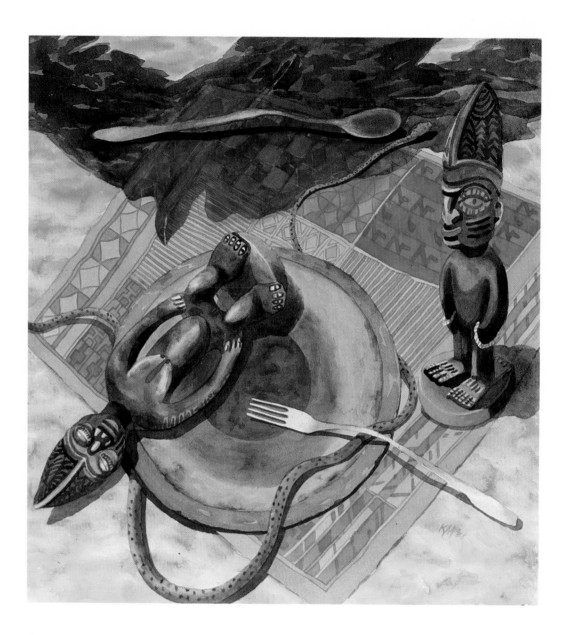

Plate 7. **Keith Morrison**
 Shadow Over Africa, 1986
 watercolor
 24″ x 22″
 Brody's Gallery, Washington, D.C.

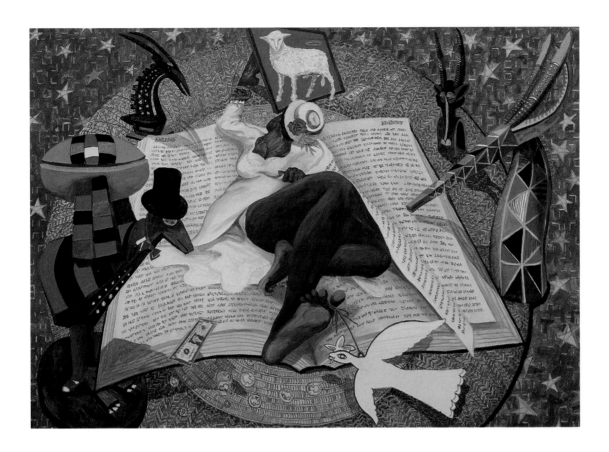

Plate 8. **Keith Morrison**
Spirituals, 1986
oil on canvas
48″ x 68″
Brody's Gallery, Washington, D.C.

Keith Morrison
Spirituals, 1986
(not reproduced here)
watercolor
22″ x 30″
Brody's Gallery, Washington, D.C.

Plate 9.　**Keith Morrison**
Ton Ton Macoute, 1986
oil on canvas
66″ x 80″
Brody's Gallery, Washington, D.C.

Keith Morrison
Ton Ton Macoute, 1986
(not reproduced here)
watercolor
22″ x 30″
Brody's Gallery, Washington, D.C.

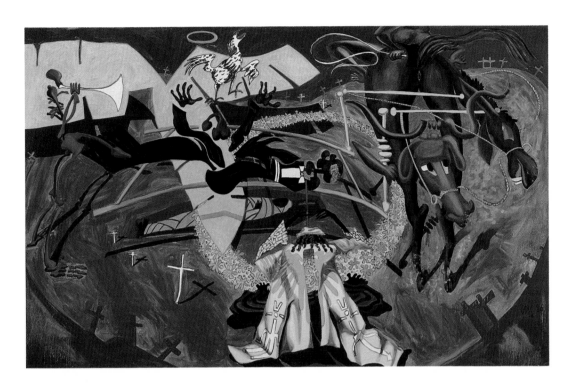

Plate 10. **Keith Morrison**
A Wreath for Udomo, 1986
oil on canvas
60″ x 96″
Brody's Gallery, Washington, D.C.

Plate 11. **William T. Williams**
Cobalt II, 1974
acrylic on canvas
84″ x 64″

Plate 12. **William T. Williams**
Equinox, 1974–75
acrylic on canvas
84″ x 60″

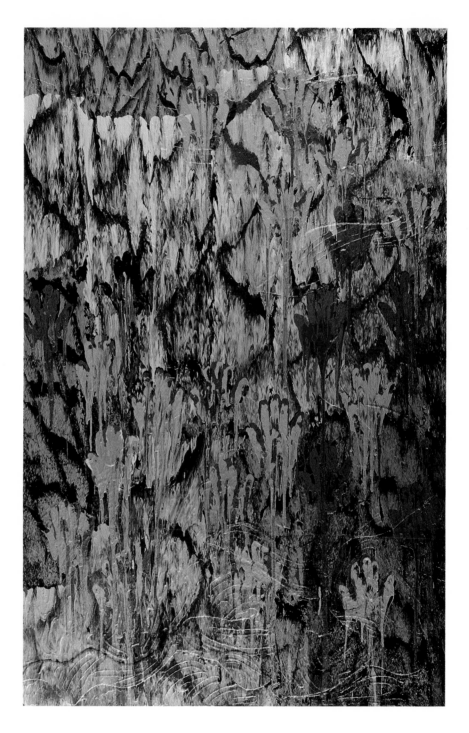

Plate 13. **William T. Williams**
Loch Ness, 1984
acrylic on canvas
84″ x 54½

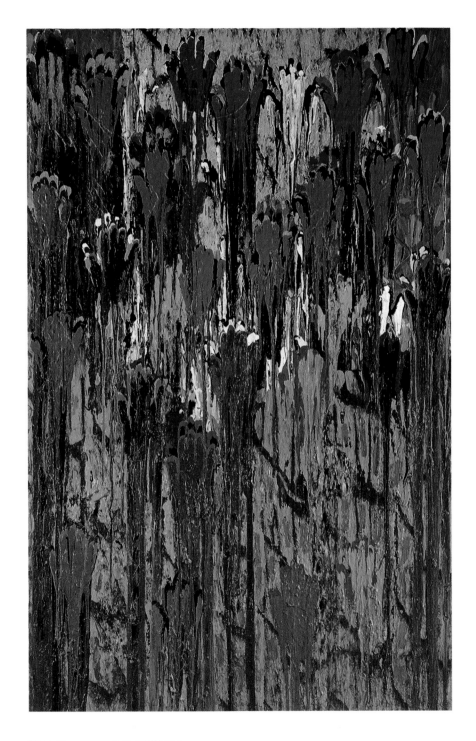

Plate 14. **William T. Williams**
A Note to Marcel Proust, 1984
acrylic on canvas
84" x 54½"

Chronology of
Artists' Exhibition History
and Selected Review Notices

Sam Gilliam

Born in Tupelo, Mississippi, in 1933. Received
B.A. and M.A. Painting from the University of
Kentucky in Louisville. Resides in Washington,
D.C.

One-Person Exhibitions

1986

Middendorf Gallery, Washington, D.C.

1985

Monique Knowlton Gallery, New York

1984

Middendorf Gallery, Washington, D.C.
Herter Gallery, University of Massachusetts,
 Amherst
McIntosh-Drysdale Gallery, Houston, Texas

1983

Galerie Darthea Speyer, Paris, France
Corcoran Gallery of Art, Washington, D.C.
Middendorf/Lane Gallery, Washington, D.C.

1982

The Studio Museum in Harlem, New York
Richard Barry Gallery, Minneapolis, Minnesota
Robert Kidd Gallery, Birmingham, Michigan
Marshall University, Huntington, West Virginia
Dart Gallery, Chicago, Illinois

1981

Middendorf/Lane Gallery, Washington, D.C.
The Hamilton Gallery, New York
Art Gallery, Washington University, St. Louis,
 Missouri
Nina Freudenheim Gallery, Buffalo, New York
Nexus Art Gallery, Atlanta, Georgia

1980

Middendorf/Lane Gallery, Washington, D.C.
Dart Gallery, Chicago, Illinois
Miami-Dade Public Library, Miami, Florida
University of Wisconsin, Stevens Point

1979

Hamilton Gallery of Contemporary Art, New York
Middendorf/Lane Gallery, Washington, D.C.
Dart Gallery, Chicago, Illinois
Nina Freudenheim Gallery, Buffalo, New York
Florence Duhl Gallery, New York
Montgomery Community College, Rockville,
 Maryland

1978

Carl Solway Gallery, New York
Fendrick Gallery, Washington, D.C.
University of Kentucky, Lexington
University Gallery, University of Massachusetts,
 Amherst
Galerie Darthea Speyer, Paris, France
Virginia Commonwealth University, Richmond
The Arnold Gallery, Atlanta, Georgia

1977

Pennsylvania State University, University Park

Dart Gallery, Chicago, Illinois
Artpark, Lewiston, New York
Oliver Dowling Gallery, Dublin, Ireland

1976

Fendrick Gallery, Washington, D.C.
Rutgers University Art Gallery, New Brunswick, New
 Jersey
J.B. Speed Art Museum, Louisville, Kentucky
Nina Freudenheim Gallery, Buffalo, New York
Galerie Darthea Speyer, Paris, France

1975

Fendrick Gallery, Washington, D.C.
Philadelphia Museum of Art, Philadelphia,
 Pennsylvania
Collector's Gallery, Stevenson, Maryland
Linda Ferris Gallery, Seattle, Washington

1974

Fendrick Gallery, Washington, D.C.
Carl Solway Gallery, Cincinnati, Ohio
Phoenix Gallery, San Francisco, California
Linda Ferris Gallery, Seattle, Washington

1973

Jefferson Place Gallery, Washington, D.C.
Maison de la Culture, Rennes, France
University of California, Irvine
Fendrick Gallery, Washington, D.C.
Howard University, Washington, D.C.
The Greenberg Gallery, St. Louis, Missouri

1972

Jefferson Place Gallery, Washington, D.C.

1971

Museum of Modern Art, New York

1970

Jefferson Place Gallery, Washington, D.C.
Gallerie Darthea Speyer, Paris, France

1969

Corcoran Gallery of Art, Washington, D.C.

1968

Byron Gallery, New York

1967

Phillips Collection, Washington, D.C.

Group Exhibitions

1985

"Artistic Collaboration," The Water Tower Art
Association, Louisville, Kentucky

1984

"Black History Month," University of Virginia,
Charlottesville

"Black Artists—Harlem Renaissance," Bucknell
University Center Gallery, Lewisburg,
Pennsylvania

"Surfaces," Creiger Sesen Associated, Inc., Boston,
Massachusetts

1983

"Dimensional Aspects of Painting," Klein Gallery,
Chicago, Illinois

1982

"10 + 10 + 10," Corcoran Gallery of Art,
Washington, D.C.

"American Abstraction Now," Virginia Museum of
Fine Arts, Richmond

"Painterly Abstraction," Fort Wayne Museum of Art,
Indiana

1981

"Installations: Stephen Antonakos, Sam Gilliam,
Rockne Krebs," Middendorf/Lane Gallery,
Washington, D.C.

"Sam Gilliam and Auste," Hamilton Gallery, New
York

1980

"Six Black Americans," New Jersey State Museum,
Trenton

"Afro-American Abstraction," P.S. 1, Queens, New
York

"Alternatives by Black Artists," W.P.A. Gallery,
Washington, D.C.

"Arts on the Line: Art for Public Transit Spaces,"
Hayden Gallery, Massachusetts Institute of
Technology, Cambridge

"Fabric into Art," State University of New York,
College at Old Westbury, New York

"Fabrications," Lowe Art Museum, Miami, Florida

"Aspects of the 70's: Spiral," Museum of the Center
of Afro-American Artists, Inc., Boston,
Massachusetts

Third Floor Gallery, in conjunction with opening of
Atlanta Airport, Atlanta, Georgia

"Planar Painting Constructs," The Alternative
Museum, New York

1979

"Color and Structure," Hamilton Gallery of
Contemporary Art, New York

"Art of the Eighties," Grey Gallery, New York

1978

"American Black Artists," Dade County Library,
Miami, Florida

"Foulkes/Gilliam," Galerie Darthea Speyer, Paris,
France

"Paper," The Dayton Art Institute, Ohio

"American Artists' Work in Private French
Collections," Museum of Modern Art, Lyon,
France

1977

"Le Peintre et le Tissu," Museum of Modern Art,
Lyon, France

Twelfth International Biennial of Graphic Art,
Ljubljana, Yugoslavia

"New in the Seventies," University of Texas, Austin

1976

"Resonance-Williams/Edwards/Gilliam," Morgan
State University, Baltimore, Maryland

"Seventy-second American Exhibition," Art Institute
of Chicago, Illinois

"Thirty Years of American Printmaking," The
Brooklyn Museum, New York

1975

"Thirty-fourth Biennial of Contemporary American Painting," Corcoran Gallery of Art, Washington, D.C.

1974

"ART NOW," The Kennedy Center, Washington, D.C.

"Cut, Bend, Spindle, Fold," Museum of Modern Art, New York

EXPO-74, Spokane, Washington

"Gilliam/Edwards/Williams: Extensions," Wadsworth Atheneum, Hartford, Connecticut

"Tokyo Print International," Tokyo, Japan

"Black Artists," University of California, Fresno

1973

"Works for Spaces," The San Francisco Museum of Art, California

1972

XXXVIth Venice Biennial, American Pavilion, Italy

"Color Forum," University of Texas Museum, Austin

1971

"American Exhibit, Indiana Triennial," New Delhi, India

"Works for New Spaces," Walker Art Center, Minneapolis, Minnesota

"Kids' Stuff," Albright-Knox Gallery, Buffalo, New York

"Deluxe Show," Deluxe Theatre Exhibit, Houston, Texas

"Eight Washington Artists," Columbia Museum of Art, South Carolina

"Washington Art," Madison Art Center, Wisconsin

1970

"Sixty-ninth American Exhibition," The Art Institute of Chicago, Illinois

"Ten Washington Artists: 1950–1970," The Edmonton Art Gallery, Edmonton, Alberta, Canada

"Works on Paper," Museum of Modern Art, New York

"Washington: Twenty Years," Baltimore Museum of Art, Maryland

1969

"X to the Fourth Power," The Studio Museum In Harlem, New York

"Annual Exhibition of Contemporary American Painting," Whitney Museum of American Art, New York

"Gilliam, Krebs, McGowin," Corcoran Gallery of Art, Washington, D.C.

"The Washington Painters," Ringling Museum, Sarasota, Florida

"Other Ideas," Detroit Institute of Art, Michigan

1968

"Tribute to Martin Luther King," Museum of Modern Art, New York

"Inaugural Show," The Studio Museum In Harlem, New York

"Art in Washington," Washington Gallery of Modern Art, Washington, D.C.

"Thirty Contemporary Black Artists," Minneapolis Institute of Art, Minnesota

1967

"Art for Embassies," Washington Gallery of Modern Art, Washington, D.C.

1966

"Artists in Washington," Institute of Contemporary Arts, Washington, D.C.

"The Negro in American Art," University of California in Los Angeles Galleries, Los Angeles

"First World Festival of Negro Arts," Dakar, Senegal

1964

"Nine Contemporary Painters USA," Pan American Union, Washington, D.C.

1961

New Albany Art Festival, New Albany, Indiana

"Art Center Annual," The J.B. Speed Art Museum, Louisville, Kentucky

1959

Art in Louisville House, Louisville, Kentucky

1955

"Art Center Annual," Louisville, Kentucky

Selected Bibliography

Jane Addams Allen, "Letting Go," *Art in America,* January 1986.

Eleanor Heartney, "Old Masters of Abstraction Meet The Eighties," *New Art Examiner,* April 1985.

Gerrit Henry, "A Metaphor for Human Being: New Paintings by Sam Gilliam," *ARTS Magazine,* February 1985.

Jane Addams Allen, "Jazz-inspired Gilliam: Stretching the Rainbow," *Washington Times*, November 30, 1984.

Paul Richard, "Gilliam's Masterly 'Jazz,'" *Washington Post*, November 29, 1984.

Owen Findsen, "Tangeman Gallery Exhibition Hangs A Different Perspective On Sculpture," *Cincinnati Enquirer*, March 18, 1984.

Patricia Johnson, "Gilliam Works at McIntosh," *Houston Chronicle*, December 23, 1983.

Diane Heilenman, "U of L Seeks Sculpture by Gilliam for Library," *Courier-Journal*, December 4, 1983.

Martha McWilliams Wright, "Sam Gilliam," *New Art Examiner*, June 1983.

Jim Hettinger, "Sam Gilliam," *Unicorn Times*, April 1983.

Jane Addams Allen, "The Gilliam Genius Gets Even Bolder," *Washington Times*, March 25, 1983.

Paul Richard, "Sam Gilliam's Show at the Corcoran: Proof of His Power and Significance As a Washington Color Painter," *Washington Post*, March 24, 1983.

Mason Riddle, "Sam's Shapes," *City Pages*, November 17, 1982.

Michael Days, "Sam Gilliam, ex-Louisvillian, is Returning to the Paintbrush," *Courier-Journal*, October 31, 1982.

Steve Sonsky, "Chaos on Canvas," *Miami Herald*, February 15, 1982.

Kay Larson, "Skin-Deep," *New York*, March 23, 1981.

Rosalind Solomon, "Sam Gilliam," *Washington Review*, December 1980 thru January 1981.

Jo Ann Lewis, "Gilliam in Fine Shapes," *Washington Post*, October 25, 1980.

Keith Morrison, "The Emerging Importance of Black Art in America," *The New Art Examiner*, June 1980.

Hugh Davies, "Sam Gilliam," *ARTS Magazine*, March 1979.

Clarissa Wittenberg, "Sam Gilliam at Fendrick Gallery," *Art Voices/South*, May thru June 1978.

Jay Kloner, "Sam Gilliam: Recent Black Paintings," *Arts* 52, February 1978.

Vivian Raynor, "Review," *New York Times*, January 20, 1978.

Grace Glueck, "The Twentieth Century Artists Most Admired by Other Artists," *Art News*, November 1977.

David Tannous, "New Mastery, Old Techniques, Fresh Concepts," *Washington Star*, December 19, 1976.

Doris Brown, "Draped Paintings Improvisation in Art," *New York Times*, November 14, 1976.

David Bourdon, "Pulp Artists Paper MOMA," *Village Voice*, August 23, 1976.

Le Festival International de la Peinture, Cagnes-sur-Mer, France, 1975.

Benjamin Forgey, "Energy is the Catalyst in Sam Gilliam's Formula," *Washington Star*, October 19, 1975.

Benjamin Forgey, "The Thirty-fourth Corcoran Biennial," *Art News* 74, May 1975.

Benjamin Forgey, "D.C. Artist Aids Philadelphia," *Washington Star*, April 25, 1975.

Gilliam/Edwards/Williams: Extension, Wadsworth Atheneum, Hartford, Connecticut, 1974.

Deloris Tarzan, "Sam Gilliam's Draperies Collaborate with the Future," *Seattle Times*, August 18, 1974.

Vivian Raynor, "The Art of Survival (and vice versa)," *New York Times Magazine*, February 17, 1974.

Drawings and Small Works, Washington Gallery of Art, Washington, D.C., 1973.

Theresa Dickason, *Afro-American Artists: A Bio-bibliographical Directory*, Boston Public Library, 1973.

Judith Dunham, "Works in Spaces," *West Coast Artweek*, March 1973.

Diane Arbus, Ron Davis, Richard Estes, Sam Gilliam, James Nutt, Keith Sonnier, Venice, 36th International Biennial Exhibition of Art, U.S.A., 1972.

Edwards, Gilliam, Williams, Wabash Transit Gallery, Chicago School of Art, The Art Institute of Chicago, Illinois, 1972.

Paul Richard, "Six Artists for Biennale," *Washington Post*, April 20, 1972.

II Indian Triennale. Lalit Kala Adademi, New Delhi, India, 1971.

Lucille Naime, "Projects: Sam Gilliam at MOMA," *Arts* 46, December 1971.

Sarah Lansdell, "Sam Gilliam Drapes a New York Museum," *Louisville Courier-Journal*, November 28, 1971.

M. Pleynet, "Galerie Darthea Speyer, Paris Exposition," *Art International*, January 1971.

"Object Diversity," *Time*, April 6, 1970.

Carroll Greene, Jr., "Perspective: The Black Artist in America," *Art Gallery*, April 1970.

Paul Richard, "Corcoran's Stunning Show," *Washington Post*, October 4, 1969.

Douglas Davis, "This is the Loose Paint Generation," *National Observer*, August 4, 1969.

Grace Glueck, "Negroes' Art Is What's In Just Now," *New York Times*, February 27, 1969.

"The Black Artist in America: A Symposium,"

Metropolitan Museum of Art Bulletin, January 1969.

Thirty Contemporary Black Artists. Minneapolis Institute of Arts, Minnesota. New York: Ruder and Finn, 1968.

"Sam Gilliam," *Time*, June 7, 1968.

John Canaday, "Review," *New York Times*, June 1, 1968.

Paul Richard, "Fine Young Color Painter Has A One-Man Show," *Washington Post*, November 5, 1967.

Benjamin Forgey, "Sam Gilliam Bursts Forth at Phillips," *Washington Star*, October 22, 1967.

Tom Harney, "When He Paints, He Pours," *Washington Daily News*, October 13, 1967.

Paul Richard, "Sam Gilliam's Restless Art Cuts a Trail of Its Own," *Washington Post*, August 6, 1967.

Andrew Hudson, "Major Breakthrough for Capitol," *Washington Post*, November 30, 1966.

Cornelia Noland, "Meet the Artist: Sam Gilliam," *Washingtonian*, October 1965.

Lawrence Alloway, "Seven U.S. Painters," *Americas*, July 1964.

Collections

Atlanta, Georgia

High Museum

Baltimore, Maryland

Baltimore Museum of Art

Chicago, Illinois

Art Institute of Chicago

Denver, Colorado

Denver Art Museum

Iowa City, Iowa

University of Iowa

Madison, Wisconsin

Madison Art Center

Minneapolis, Minnesota

Walker Art Center

New Brunswick, New Jersey

Rutgers University

New York, New York

The Metropolitan Museum of Art

Museum of Modern Art

Rockefeller Collection

Oberlin, Ohio

Oberlin University

Pittsburgh, Pennsylvania

Carnegie Institute

Washington, D.C.

Corcoran Gallery of Art

Gallery of Modern Art

Hirshhorn Museum and Sculpture Garden, Smithsonian Institution

Howard University

IBM

National Museum of African Art, Smithsonian Institution

National Museum of American Art, Smithsonian Institution

Phillips Collection

Woodward Foundation, Embassy Collection

London, England

Tate Gallery

Paris, France

Musee d'Art Moderne de la Ville de Paris

Rotterdam, Holland

Boymans and Van Beunigen Museum

Martha Jackson-Jarvis

Born in Lynchburg, Virginia, in 1952. Received B.F.A. from Tyler School of Art, Temple University, Philadelphia, Pennsylvania, and M.F.A. from Antioch University, Columbia, Maryland. Resides in Washington, D.C.

One-Person Exhibitions

1983

"East of the Sun West of the Moon," Washington Project for the Arts, Washington, D.C.

1977

African American Historical Museum, Philadelphia, Pennsylvania

Group Exhibitions

1986

"The Other Gods," The Everson Museum, Syracuse, New York

"Generations in Transition," Chicago Museum of Science and Industry, Illinois

1985

"Evocative Abstractions," Nexus Foundation for Contemporary Art, Philadelphia, Pennsylvania

"Collaborations," Dade County Public Library, Miami, Florida

1984

"East/West: Afro-American Contemporary Art," California Afro-American Museum, Los Angeles

"Washington Sculpture," Georgetown Court Artist Space, Washington, D.C.

1983

"Installations," Maryland Art Place, Baltimore

Franz Bader Gallery, Washington, D.C.

1981

"Cosmic Garden," Howard University, Washington, D.C.

Pleaides Gallery, New York

1980

National Sculpture Conference, Sculpture 80, Baltimore, Maryland

"Alternatives," Washington Project for the Arts, Washington, D.C.

1979

Brooks Memorial Museum, Memphis, Tennessee

1978

Gallery 10 LTD., Washington, D.C.

1974

University of Pennsylvania Museum, Philadelphia

Selected Bibliography

Lee Fleming, "Myth + Ritual," *Washington Review,* April/May 1986.

Jane Addams Allen, "Sculptors Divided on D.C. State of the Art," *Washington Times Magazine,* August 12, 1983.

Jane Addams Allen, "Some New Species from Local Innovator," *Washington Times,* August 11, 1983.

"Galleries," *Washington Post,* August 4, 1983.

Paul Richard, "The Power and the Spirit," *Washington Post,* February 19, 1983.

Jane Addams Allen, "Overcoming the Uglies with Mixed Media Images," *Washington Times,* February 18, 1983.

Benjamin Forgey, "Intriguing Ingenuity At WPA," *Washington Post,* February 17, 1983.

Keith Morrison

Born in Linstead, Jamaica, in 1942. Received a B.F.A. and M.F.A. from the Art Institute of Chicago, Illinois. Resides in Washington, D.C.

One-Person Exhibitions

1987

Brody's Gallery, Washington, D.C.

1985

HarrisBrown Gallery, Boston, Massachusetts

1979

Jan Cicero Gallery, Chicago, Illinois
Organization of African Unity (OAU), Monrovia, Liberia

1978

Chicago State University, Illinois

1976

"Works on Paper," DePaul University Gallery, Chicago, Illinois

1975

South Side Art Center, Chicago, Illinois
Illinois State Arts Council, Chicago

1974

Carl Van Vechten Gallery, Fisk University, Nashville, Tennessee

1967

Harper Gallery, Chicago, Illinois

Group Exhibitions

1987

Butler Institute of American Art, Youngstown, Ohio
Midland Arts Council, Midland Center for the Arts, Michigan

1986

Millersville University, Pennsylvania
HarrisBrown Gallery, Boston, Massachusetts
High Museum Georgia Pacific Center, Atlanta
"Choosing," Portsmouth Art Center, Virginia
California Museum of Afro-American Art, Los Angeles
University of South Carolina, Columbia
Chicago State University, Illinois
Museum of Fine Arts, St. Petersburg, Florida
Chicago Museum of Science and Industry, Illinois

1985

Art Institute of Chicago, Contemporary Art Gallery, Illinois
Tyler Gallery of Art, Temple University, Philadelphia, Pennsylvania
"Encore," HarrisBrown Gallery, Boston, Massachusetts
"Evocative Abstraction," Nexus Gallery, Philadelphia, Pennsylvania
"Installations," Miami-Dade Library Gallery, Florida
"History in the Making," Parent Association Art Gallery, University of Maryland, College Park

1984

"East/West: Afro-American Contemporary Art," California Afro-American Museum, Los Angeles
"Profiles," University of Maryland Art Gallery, College Park
Ninth International Drawing Exhibition, Museum of Modern Art, Rijeka, Yugoslavia
Crystal Britten Gallery, Atlanta, Georgia
Fifth National Juried Exhibition, Atlanta Life Company, Georgia
Bayly Museum, University of Virginia, Charlottesville

1983

"Art as Image of America," Indiana University of Pennsylvania, Indiana, Pennsylvania
Jan Cicero Gallery, Chicago International Arts Festival, Illinois
"Four Artists," University of Maryland Art Gallery, College Park

1982

"10 + 10 + 10," Corcoran Gallery of Art, Washington, D.C.
Carl Van Vechten Gallery, Fisk University, Nashville, Tennessee
Northern Virginia Community College, Annandale
Alma Thomas Memorial Gallery, Washington, D.C.

1981

"Washington Artists on Paper," National Democratic Club, Washington, D.C.

Jan Cicero Gallery, Chicago, Illinois

1980

"Chicago Abstraction," Gallerie Tillie Hardek, Karlchrue, Germany

1978

NAME Gallery, Chicago, Illinois

1977

Renaissance Society Gallery, University of Chicago, Illinois

Hyde Park Art Center, Chicago, Illinois

NAME Gallery, Chicago, Illinois

Battle Creek Museum, Michigan

Washington State University, Pullman, Washington

Albany Institute of American History and Culture, Albany, New York

Iowa State University, Ames

Jesse Besser Museum, Alpena, Michigan

1976

Princeton University, New Jersey

Colorado Springs Fine Arts Center, Colorado

Illinois State University, Normal

University of Cincinnati, Ohio

"Chicago Art," Union Gallery, Purdue University, Lafayette, Indiana

"Second Drawing Invitational," NAME Gallery, Chicago, Illinois

State Capitol Museum, Jackson, Mississippi

Birmingham Museum of Art, Alabama

Brooks Memorial Art Gallery, Memphis, Tennessee

Columbus Fine Arts Gallery, Ohio

Milwaukee Center for the Performing Arts, Wisconsin

Jackson State University, Mississippi

Tougaloo College, Jackson, Mississippi

Dignity House, St. Louis, Missouri

University of Kansas, Lawrence

Kansas State University, Manhattan

L.B.J. Memorial Library, Austin, Texas

"Retrospective," Hyde Park Art Center, Chicago, Illinois

1975

Rainbow Sign Gallery, Oakland, California

"Amistad II Exhibition of Afro-American Art, 1850–1975," Fisk University, Nashville, Tennessee

University of Minnesota, St. Paul

South Street Seaport Museum, New York

The Studio Museum in Harlem, New York

1974

"Chicago Printmakers," Hyde Park Art Center, Chicago, Illinois

University of Tennessee, Martin

University of Tennessee, Knoxville

State College in Cleveland, Ohio

"Fifty Years of Black Aesthetics," Chicago Museum of Science and Industry, Illinois

1972

Twenty-fifth Illinois Invitational," Illinois State Museum, Springfield

1971

Art Institute of Chicago, Illinois

Butler Institute of American Art, Youngstown, Ohio

University of Wisconsin, Milwaukee

Sloan Gallery, Valpariso, Indiana

Malcolm X College, Chicago, Illinois

Davenport Municipal Gallery, Iowa

Smith-Mason Gallery, Washington, D.C.

New Jersey State Museum, Trenton

"Black Artists '71," Illinois Bell Telephone Company, Chicago

1970

Cornell University, Ithica, New York

University of Alabama

1969

"Black and White," Kovler Gallery, Chicago, Illinois

"Chicago Prints," Allan Frumkin Gallery, Chicago, Illinois

Atlanta University, Georgia

"Thirtieth Anniversary International," Hyde Park Art Center, Chicago, Illinois

1968

DePaul University Art Gallery, Chicago, Illinois

Stephens College, Columbia, Missouri

Vanderbilt University Art Gallery, Nashville, Tennessee

Jarvis Christian College, Hawkins, Texas

"Grande Jatte," Practicing Artists of Chicago, Illinois

Institute of Technology, Chicago

South Side Art Center, Chicago, Illinois

1966

"Chicago Drawings," Art Institute of Chicago, Illinois

"Phalanx IV," Illinois Institute of Technology, Chicago

"Festival of the Arts," University of Chicago, Illinois

1963

"Drawings," Washington University, St. Louis, Missouri

Selected Bibliography

"Editorial," *New York Times,* February 1, 1987.

Jo Ann Lewis, "The Myth Masters," *Washington Post,* March 4, 1986.

E.K. Lang, *Christian Science Monitor,* November 20, 1985.

Paul Richard, *Washington Post,* April 14, 1985.

Jane Allen, "The Black Legacy to Washington Art," *Washington Times,* April 4, 1985.

David Tannous, *Art in America,* October 1983.

Paul Richard, *Washington Post,* February 19, 1983.

Jane Addams Allen, "Overcoming the Uglies with Mixed Media Images," *Washington Times,* February 18, 1983.

Joanne Ostrow, "The Black Conundrum," *Afro-Am,* January thru March 1983.

Clara Hieronymous, *Nashville Tennessean,* October 17, 1982.

Benjamin Forgey, *Washington Star,* November 21, 1980.

Benjamin Forgey, *Washington Star,* April 29, 1980.

Dereck Guthrie, "Keith Morrison," *New Art Examiner,* March 1976.

David C. Driskell, "Afro-American Art," *Smithsonian,* Winter 1975.

Dennis Adrian, *Chicago Sun-Times,* April 10, 1975.

Robert Sengstacke, "Keith Morrison at South Side Center," *Chicago Defender,* October 8, 1974.

Clara Hieronymous, *Nashville Tennessean,* March 24, 1974.

Franz Schulze, "The Us vs. Them in Chicago Art," *Chicago Daily News,* January 30, 1974.

"Editorial," *Chicago Defender,* January 10, 1974.

Harold Haydon, "Art Institute's 73rd Young, Fashionable," *Chicago Tribune,* March 21, 1971.

Kitty Kingston, *Daily Gleaner* (Jamaica), February 10, 1971.

"Editorial," *Chicago Sun-Times,* January 24, 1971.

Robin Glauber, "Keith Morrison's Black and White Abstractions," *Skyline,* September 30, 1970.

Mary Pat Hough, *Chicago Tribune,* June 6, 1969.

Doris Saunders, *Chicago Defender,* May 12, 1969.

Franz Schulze, *Chicago Daily News,* February 12, 1969.

Kitty Kingston, *Daily Gleaner* (Jamaica), January 25, 1969.

Collections

Chicago, Illinois

Art Institute of Chicago

Burrell Advertising

Dusable Museum

Johnson Collection

Nashville, Tennesee

Fisk University

Philadelphia, Pennsylvania

Philadelphia Museum of Afro-American Art and Culture

Talladega, Alabama

Talladega College

Washington, D.C.

Corcoran Gallery of Art

Washington Post Collection

Jamaica

National Gallery of Jamaica

West Indies

University of the West Indies

William T. Williams

Born in Fayetteville, North Carolina, in 1942.
Received B.F.A. Painting from Pratt Institute,
Brooklyn, New York, and M.F.A. Painting from
School of Art and Architecture, Yale University,
New Haven, Connecticut. Resides in New York.

One-Person Exhibitions

1985

Southeastern Center for Contemporary Art, Winston-
Salem, North Carolina

1981

Touchstone Gallery, New York

1980

University of Wisconsin, Memorial Union Gallery,
Madison

1979

University of Wisconsin/Stout Art Gallery,
Menomonie

1977

Miami-Dade Community College Art Gallery, Florida

1976

Center for the Visual Arts Gallery, Illinois State
University, Normal
Carlton Gallery, New York

1975

Carl Van Vechten Gallery, Fisk University, Nashville,
Tennessee

1971

Reese Palley Gallery, New York

Group Exhibitions

1986

"A Generation in Transition," Chicago Museum of
Science and Industry, Illinois
"Transitions: The Afro-American Artist," Bergen
Museum of Art, Paramus, New Jersey

1985

Thirty-seventh Annual Purchase Exhibition, Hassam
and Speicher Fund, American Academy and
Institute of Arts and Letters
"Through a Master Printer—The Printmaking
Workshop," traveling exhibition, Columbia
Museum of Art, South Carolina; Arkansas Art
Center, Little Rock; Mississippi Museum of Art,
Jackson
"New Color Abstractions," Cleveland State
University Art Gallery, Ohio

1984

"Since The Harlem Renaissance," traveling
exhibition, The Art Center, Bucknell University,
Lewisberg, Pennsylvania; The State University of
New York, Old Westbury, New York; The
University of Maryland Art Gallery, College Park;
Munson-Williams-Proctor Museum, Utica, New
York; The Chrysler Museum, Norfolk, Virginia;
Gray Art Gallery, New York University, New York
"East-West: Contemporary American Art," The
California Afro-American Museum, Los Angeles
"In a Stream of Ink," traveling exhibition, Dillard
University, New Orleans, Louisiana; Lehman
College, Bronx, New York; The Afro-American
Museum of Culture, Dallas, Texas; Center for Art
and Culture, Bedford Stuyvesant, Inc., New York

1983

"New Acquisitions and Promised Gifts," The Studio
Museum in Harlem, New York
"The Art Mobile, Skowhegan Series," Miami-Dade
Library Systems, Florida
"Just Jazz," Kenkeleba Gallery, New York

1982

"Recent Acquisitions of the Schomburg Collection,"
Schomburg Center for Research in Black Culture,
New York
"Afro-American Abstractions," traveling exhibition,
Los Angeles Municipal Art Gallery, California;
Oakland Museum, California; Brooks Memorial
Art Gallery, Memphis, Tennessee; Art Center,
South Bend, Indiana; Toledo Museum of Art, Ohio;
Bellevue Art Museum, Washington; New Orleans
Museum at the World's Fair, Louisiana

1981

"Abstract Painting, New York City, 1981," Emily
Lowe Gallery, Hofstra University, Hempstead, New
York
"Afro-American Abstraction," Everson Museum,
Syracuse, New York

"Winners All," Pratt Institute Gallery, Brooklyn, New York

"1981 Caps Painting Show," Munson-Williams-Proctor Museum, Utica, New York

"Afro-American Artist," Goucher College Art Gallery, Towson, Maryland

1980

"Islamic Allusions," Alternative Museum, New York

"Retour Aux Sources," Galerie d'Art Mitkal, Abidijan, Cote d'Ivoire

"Afro-American Abstraction," Institute for Art and Urban Resources–P.S. 1, New York

"Dialects," Franklin Furnace, New York

"Color and Surface," Touchstone Gallery, New York

"The Nineteen Seventies: Prints and Drawings," Museum of the National Center, Dorchester, Massachusetts

1979

"A Skowhegan Selection," University of Maryland Art Gallery, College Park

"New Sensibilities," 22 Wooster Street Gallery, New York

"Recent Works," Alternative Center for International Arts, New York

"Another Generation," The Studio Museum in Harlem, New York

1978

"Print Portfolio," Brooklyn College Art Department, Neuberger Museum, New York

"New Dimensions," Miami-Dade Public Library System, Florida

"Artists Salute Skowhegan," Kennedy Galleries, New York

1977

"Selective Alumni," Pratt Institute Gallery, Brooklyn, New York

"Brooklyn College Art Department, Past and Present, 1942–1977," Davis and Long Company, Robert Schoelkopf Gallery, New York

"Second World Black and African Festival of Art and Culture," National Museum and Theatre, Lagos, Nigeria

1976

"A Selection of American Art, 1946–76, The Skowhegan School," The Institute of Contemporary Art, Boston, Massachusetts

1975

"24 x 24″, Sarah Lawrence Gallery, Bronxville, New York

"Amistad II: Afro-American Art," Fisk University, Nashville, Tennessee

1974

"Extensions," Wadsworth Atheneum, Hartford, Connecticut

1972

"Interconnections," Wabash Transit Gallery, The Art Institute of Chicago, Illinois

"Painting and Sculpture Today," Indianapolis Museum of Art, Indiana

"Drawings by New York Artists," traveling exhibition, Utah Museum of Fine Art, University of Utah, Salt Lake City; Henry Gallery, University of Washington, St. Louis, Missouri; University Art Collections, Arizona State University, Tempe; Georgia Museum of Art, University of Georgia, Athens; Finch College Museum of Art, Contemporary Wing, New York; Hyden Gallery, Massachusetts Institute of Technology, Cambridge

"Small Works," Museum of Modern Art, New York

"Acquisitions," Museum of Modern art, New York

1971

"Deluxe Show," Menil Foundation, Houston, Texas

"Kolner Konstmerkt," Cologne, Germany

"Structure of Color," Whitney Museum of American Art, New York

"Some American History," Menil Foundation, Houston, Texas

1970

"Using Walls," Jewish Museum, New York

"L'Art Vivant Aux Etats-Units," Foundation Maeght, St. Paul, France

1969

"Critic's Choice 1969–70," Organized by Irving Sandler, New York

"American Contemporary Art," American Embassy Moscow, Museum of Modern Art, New York

"New Acquisitions," Museum of Modern Art, New York

Whitney Museum of American Art, Biennial Exhibition, New York

"Five Plus One," State University at Stonybrook, Stonybrook, New York

"Young Artists from the Charles Cowles Collection," Larry Aldrich Museum, Ridgefield, Connecticut

"X to the Fourth Power," The Studio Museum in Harlem, New York

"Inaugural Show," The Studio Museum in Harlem, New York

Selected Bibliography

H.W. Janson, *The History of Art*, 3d ed., Harry Abrams, 1986.

"Since the Harlem Renaissance—50 Years of Afro-American Art." Center Gallery of Bucknell University, 1985.

"William T. Williams." Southeastern Center for Contemporary Art, 1985.

"Dialogue—An Art Journal," January thru February 1985.

Stella Pandell Russell, *Art in the World*. Holt, Rinehart and Winston, 1984.

"East-West Contemporary American Art." California Afro-American Museum, 1984.

"The Permanent Collection of The Studio Museum in Harlem," 1982.

Dore Ashton, *American Art Since 1945*. Oxford University Press, 1982.

April Kingsley, "From Explosion to Implosion: The Ten Year Transition of William T. Williams," *Art Magazine*, February 1981.

Judith Wilson, "A Serene Indifference," *Village Voice*, January 21, 1981.

John Perreault, "Mideast Pipeline," *Soho Weekly News*, January 14, 1981.

John Perreault, "Positively Black," *Soho Weekly News*, February 27, 1980.

David C. Driskell, "William T. Williams," University of Wisconsin Publication, 1980.

Carrie Rickey, "Singular Work, Double Blind, Triple Threat," *Village Voice*, March 3, 1980.

"Contextures," Goode-Bryant and Philips, 1978.

Dore Ashton, "William T. Williams," Miami-Dade Community College Publication, November 1977.

"A Selection of American Art—The Skowhegan School 1946—76," Institute of Contemporary Art, Boston, Massachusetts, 1976.

David C. Driskell, *Amistad II: Afro-American Art*, 1975.

Jacquelyn Days Sewer, "Extensions," Wadsworth Atheneum, 1974.

Elsa Honig Fine, *The Afro-American Artist—A Search for Identity*. Holt, Rinehart & Winston, 1973.

Jane Cortez, "Conversation With Three Artists," *Black Orpheus* 3, 1974.

Frank Bowling, "Problems of Criticism," *ARTS Magazine* 46, no. 7.

Irving Sandler, "Visiting Artists," New York State Council on the Arts, 1972.

"Painting and Sculpture Today, 1972," Indianapolis Museum of Art.

Dore Ashton, "Drawings by New York Artists," Utah Museum of Art, 1972.

"DeLuxe Show," Menil Foundation, Houston, Texas, 1972.

"Canvases Brimming with Color," *Life*, September 1971.

Marsha Taylor, "The Structure of Color," Whitney Museum of American Art, April 1971.

"The Downtown Scene," *New York Times*, March 13, 1971.

"William T. Williams, Artist," *Bay Street Banner*, August 20, 1970.

Walter Jones, "Two Black Artists," *ARTS Magazine*, April 1970.

Dore Ashton, "Young Abstract Painters: Right On!," *ARTS Magazine*, February 1970.

"Using Walls," Jewish Museum Publication, 1970.

Frank Bowling, "Discussion on Black Art—II," *ARTS Magazine*, 1970.

Janet Bloom, "In the Museums," *ARTS Magazine*, December 1969–70.

Irving Sandler, "Critics's Choice 1969–70," New York State Council on the Arts Publication.

James Mellow, "The Black Artist; The Black Community; The White Art World," *New York Times*, June 29, 1970.

"X to the Fourth Power," *ARTS Magazine*, September 1969.

Peter Schjeldahl, "A Triumph Rather Than a Threat," *New York Times*, August 17, 1969.

Margaret Potter, "American Contemporary Art," American Embassy, Moscow, Russia Museum of Modern Art, 1969.

Collections

Albany, New York

The Empire State Collection, The State of New York

Baltimore, Maryland

Murphy Fine Arts Center, Morgan State University

Hartford, Connecticut

Wadsworth Atheneum

Houston, Texas
Menil Foundation, Rice University

Ithaca, New York
Johnson Museum, Cornell University

Miami, Florida
Miami-Dade Public Library System

Minneapolis, Minnesota
General Mills Corporation

Nashville, Tennessee
Fisk University

New Haven, Connecticut
Yale University

New Orleans, Louisiana
Civic Center Site Development Company

New York, New York
American Telephone and Telegraph Corporation
Chase Manhattan Bank Collection
The Museum of Modern Art
New York City Health and Hospital Corporation
Schomberg Center for Research in Black Culture
The Studio Museum in Harlem
Whitney Museum of American Art

Normal, Illinois
Center for the Visual Arts Museum, Illinois State
 University

Philadelphia, Pennsylvania
Sameric Theatres

Syracuse, New York
Everson Museum of Art

Waterville, Maine
Colby College Art Museum

Photographic Credits